ALAN DAVIE &
DAVID HOCKNEY

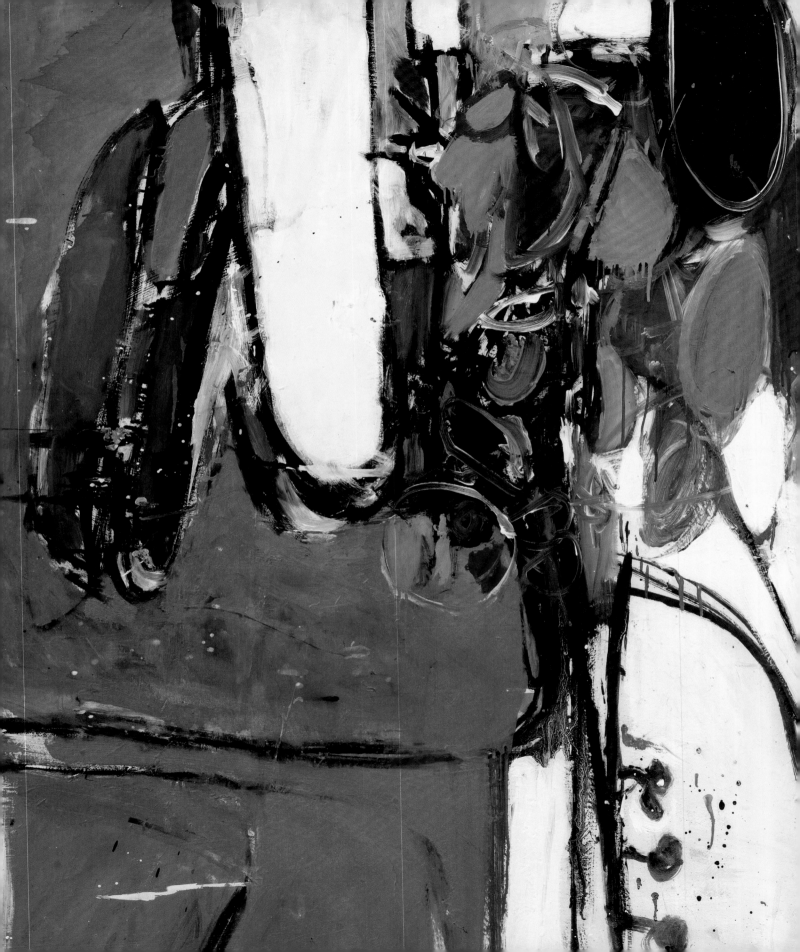

Edited by
Eleanor Clayton and Helen Little

ALAN DAVIE & DAVID HOCKNEY

Early Works

LUND
HUMPHRIES in association with THE
HEPWORTH
WAKEFIELD

First published in 2019 by Lund Humphries in association
with The Hepworth Wakefield

Lund Humphries
Office 3, Book House
261A City Road
London EC1V 1JX
UK

www.lundhumphries.com

Alan Davie & David Hockney: Early Works
© The Hepworth Wakefield, 2019
All rights reserved

ISBN 978-1-84822-375-2

A Cataloguing-in-Publication record for this book is available
from the British Library

Copy edited by Julie Gunz
Designed by Myfanwy Vernon-Hunt, this-side.co.uk
Set in Graphik
Printed in Turkey

Front cover
David Hockney
Arizona **1964**
Acrylic on canvas,
153 x 153 cm (60 x 60 ¼ in),
Private Collection

Alan Davie
Cross for the White Birds **1965**
Oil on canvas, 152 x 74 cm
(59⅞ x 29⅛ in),
Wakefield Permanent Art
Collection
(The Hepworth Wakefield).
Presented by Sir Alan Bowness
through the Art Fund, 2008

Back cover
Lord Snowdon
David Hockney 1963
National Portrait Gallery. Given
by the photographer, Antony
Charles Robert Armstrong-Jones,
1st Earl of Snowdon, 2000

Ida Kar
Alan Davie 1959
2¼ in square negative,
National Portrait Gallery, London
© Armstrong Jones Ltd

Page 2
David Hockney
Erection **(detail) c. 1959**
Oil on masonite
122 x 93 cm (48 x 36½ in)
Private Collection

Pages 6–7
Alan Davie
Glory **(detail) 1957**
Oil on canvas
172.7 x 213.3 cm (68 x 84 in)
Private Collection

Contents

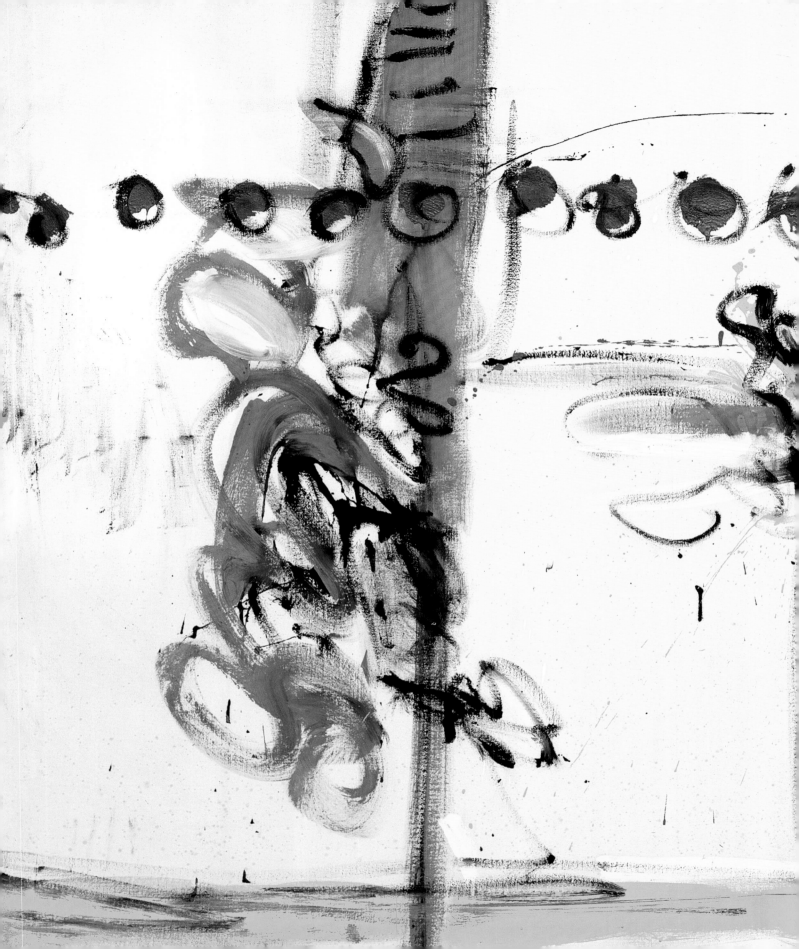

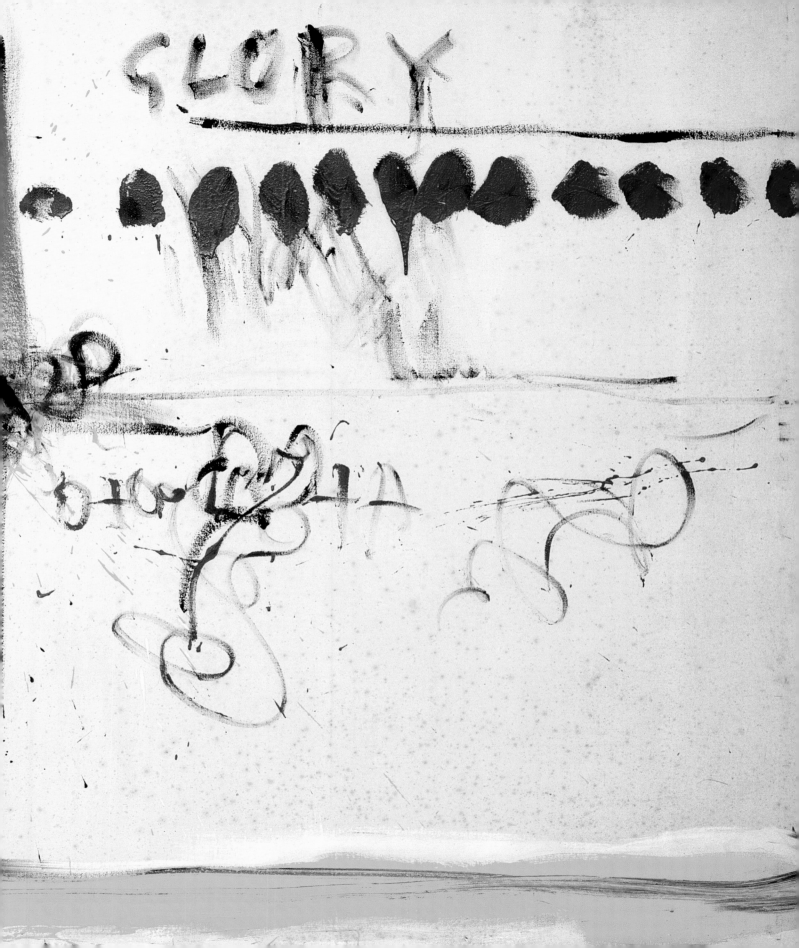

Alan Davie
Sea Gate **1960**
Oil on canvas
51 x 61 cm (20 x 24 in)
Towner Collection, Towner
Art Gallery, Eastbourne

Forewords

In 1958 a young David Hockney visited Wakefield Art Gallery and saw Alan Davie talk about the exhibition of his work then on display. This retrospective provided a significant boost to Davie's national reputation, touring to the Whitechapel Gallery in London – an iteration that is frequently referred to as his breakthrough exhibition – as well as to Liverpool and Nottingham, and was a pivotal influence on Hockney as he began his studies at the Royal College of Art. The encounter between Hockney and Davie in Wakefield offers a starting point to look at their work in the late 1950s and early 1960s and, by extension, British painting during this exciting time. Both artists shrugged off the labels of their peers, Davie refusing to be dubbed an 'abstract expressionist', and Hockney similarly eschewing the term 'pop artist'. Both pushed and tested the painted surface, playing with text and poetry, flatness and form, to create new visual languages and painterly expressions. Finally, both emerged at a time when contemporary art was gaining ground in popular culture; they appeared in films, were interviewed on television and featured in the new colour Sunday magazines. Both cultivated and presented their own version of the 'artist' persona, complete with distinctive looks, exploring differing but connected notions of masculinity and identity. This exhibition brings their works together to explore these ideas, opening a dialogue that covers passion, poetry, pop and much more.

The broad conversation points evoked by the exhibition are expanded upon in an essay by the exhibition's co-curator, Helen Little, who publishes for the first time some of her new research on little-known aspects of Alan Davie's work. The artists' parallel interest in poetry is considered by Eleanor Clayton, Curator at The Hepworth Wakefield, who revisits the verses that inspired their work. Dr Rachel Stratton then introduces a section of conversations with witnesses of this exciting cultural period. Esteemed curators, artists, collectors and critics who interacted

with both artists give a kaleidoscopic view onto a pivotal moment in British art. Our thanks go to the authors, and especially to the interviewees: Alan Bowness, Derek Boshier, Ronnie Duncan, Lindy Hamilton-Temple-Blackwood, Michael Horovitz, John Loker, Sylvia Thompson and Marina Vaizey, for giving their valuable time and memories to this project. We are enormously grateful to David Hockney for allowing us to revisit the early years of his long and expansive career.

My gratitude also goes to the team at The Hepworth Wakefield for the research, development and delivery of the exhibition: Assistant Curators Dr Hilary Floe and Dr Abi Shapiro; Collections and Exhibitions Manager Rachel Graves; Gallery Technician Karl Vickers; and Director of Engagement and Learning Nicola Freeman and Retail Development Manager, Rosie Ripley, for supporting the development and delivery of the book. The exhibition would not have been possible without the generosity of the public institutions, who have lent significant artworks to the exhibition, including: Arts Council Collection; British Council; Cartwright Hall and Bradford Museums Trust; Museum Kunstpalast, Dusseldorf; Lakeland Arts Trust; National Galleries of Scotland; National Museum Wales; and York Art Gallery (York Museums Trust), as well as the many generous private lenders and galleries, especially Alan Wheatley Fine Art. As ever, we would like to thank Wakefield Metropolitan District Council for providing insurance for the exhibition, in addition to their significant support of the gallery in general, alongside our other major funder, Arts Council England. We are delighted that *Alan Davie & David Hockney: Early Works* will travel to Towner Art Gallery in Eastbourne.

The exhibition also allows us to reflect upon the radical activities of Wakefield Art Gallery at a time when post-war austerity reigned. The Alan Davie exhibition that so inspired Hockney in 1958 was part of a programme designed to make the gallery a beacon for new, contemporary art at a time when traditional practices were overwhelmingly the norm. At The Hepworth Wakefield we aim to continue the legacy of Wakefield Art Gallery by pairing this exhibition with the first solo show in a European institution of an exciting young painter, Christina Quarles, bringing the public into contact with the new contemporary, and providing a fascinating counterpoint to this important moment in British painting.

Simon Wallis, Director, The Hepworth Wakefield

We are thrilled to be working with The Hepworth Wakefield on *Alan Davie & David Hockney: Early Works*, such is the strength and originality of this exhibition, which explores the lives and careers of two of the most innovative painters in post-war Britain. For Towner Art Gallery, the exhibition fits with our focus on 20th-century modern British art. The show represents the years between 1948 and 1965 that were crucial for Davie and Hockney in terms of their shared creative interests and their pushing at the boundaries of artistic practice. In parallel, it was a time in which many regional galleries and museums, including Towner, were also doing just that. Often in opposition to the more traditional approaches of their funders or councils, galleries were pushing for acquisitions and exhibitions of this new wave of bold and radical artists, and a new way of thinking about the arts, resulting in the wealth of innovative creative organisations that exist today.

At Towner, we are committed to exhibiting artists or collections of works that have been neglected by the mainstream. While Hockney is still exhibiting widely, Davie, who died in 2014, is less well-known, despite his paintings featuring in many public museum collections, including Towner's. *Sea Gate* 1960 (p.8), was acquired for the collection in 1962 by the then Curator William Gear, himself one of the great mid-century abstract artists. Gear was the Curator at Towner from 1958 to 1964 and during this time opened up the collection to the inclusion of a wider range of abstract works. He acquired *Sea Gate* using Gulbenkian funding alongside purchases of paintings by Sandra Blow and Peter Lanyon, followed later by Ceri Richards, Roger Hilton and Patrick Heron, among others. This resulted in Towner cementing its reputation, as *The Observer* noted in 1962, as one of the most 'go ahead municipal galleries of the time'.

We have, for some time, been keen to work with The Hepworth Wakefield, waiting for the right project to present itself. We are grateful to Director Simon Wallis, Curator Eleanor Clayton and the team at Hepworth Wakefield for their well-timed approach and delivering such an engaging project, and to co-curator Helen Little. We are also grateful to all the lenders for extending their loans and allowing their works to travel to Eastbourne.

Sara Cooper, Head of Collections, Towner Art Gallery

Love Painting / Painting Love: The Early Art of Alan Davie and David Hockney

Helen Little

Distinguished from each other and their contemporaries as mavericks committed to making their own kind of images, Alan Davie and David Hockney are not artists who find themselves grouped together art historically. 'It is difficult to think of two artists in one epoch so vastly different to each other' wrote Helen Kapp in 1971, on the occasion of the only two-man exhibition devoted to their recent work.[1] By this time, with Davie having taken his practice in a new direction in closer dialogue with the art of prehistoric cultures and Hockney's visual language becoming increasingly naturalistic and autobiographical, an interesting juncture in the evolution of their early work was overlooked. Often cited in their biographies but seldom explored in greater detail, Hockney's encounter with Davie at Wakefield Art Gallery in 1958 prompts a reconsideration of their search for artistic freedom during the hegemony of modernist painting and reveals a shared interest in passion, poetry and the expressive potential of the painted canvas. Oscillating between the parallel courses of abstraction and figuration in the late 1950s and early 1960s, the development of their imagery during this dynamic period of change in British art is ripe for re-exploration.

Alan Davie: in retrospect

Celebrated as one of the first British artists to develop an expressive form of abstraction, Alan Davie's paintings of the 1940s and 1950s represent a vital aspect of art after the Second World War. Immersing himself in the chaotic freedom of art, music and poetry, Davie is heralded for celebrating a world of imagination and beauty at odds with the post-war milieu of alienation and disaffection. Yet despite his early success – having become in 1956 the only post-war British artist

Alan Davie
Lush Life no. 1 **(detail) 1961**
Oil on canvas
213 x 173 cm (83¾ x 68 in)
National Galleries Scotland.
Presented by the artist, 1997

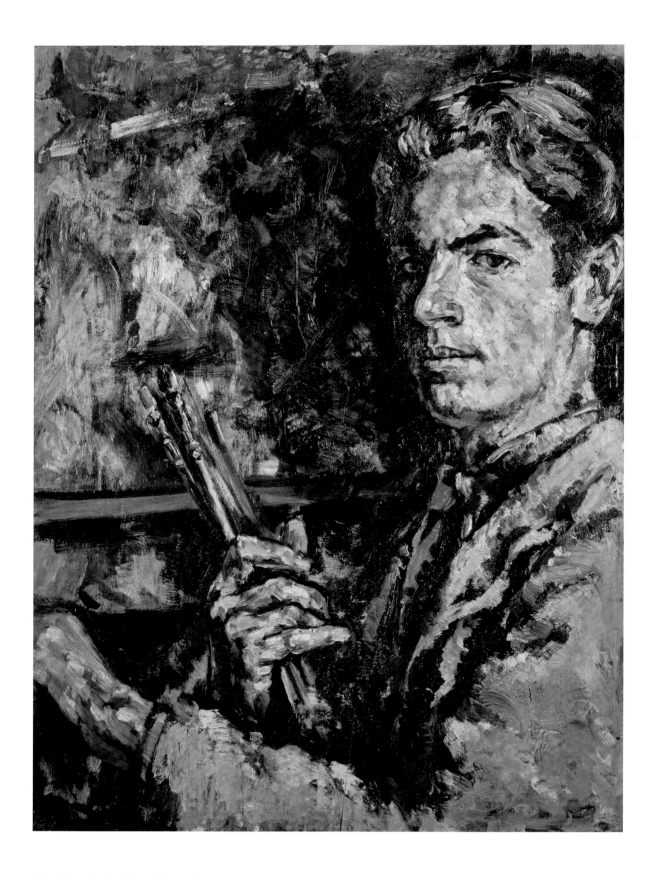

Alan Davie & **David Hockney**

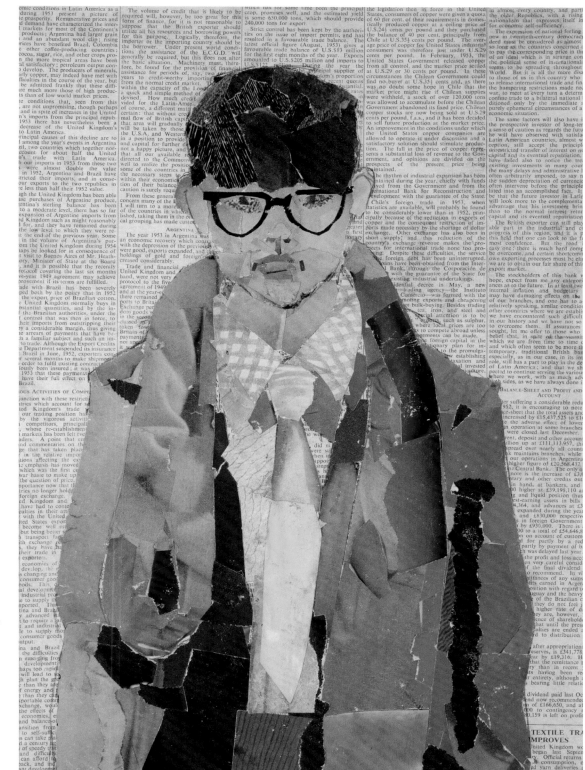

Opposite
Alan Davie
***Self Portrait No. 2 (with
Paint Brushes) 1937***
Oil on wood
61 x 46 cm (24 x 18 in)
National Galleries Scotland.
Purchased with the
support of the Heritage
Lottery Fund and the
Art Fund 1997

Right
David Hockney
Self-Portrait 1954
Collage on newsprint
42 x 30 cm (16½ x 11¾ in)
Collection Bradford
Museums & Galleries,
Bradford, UK

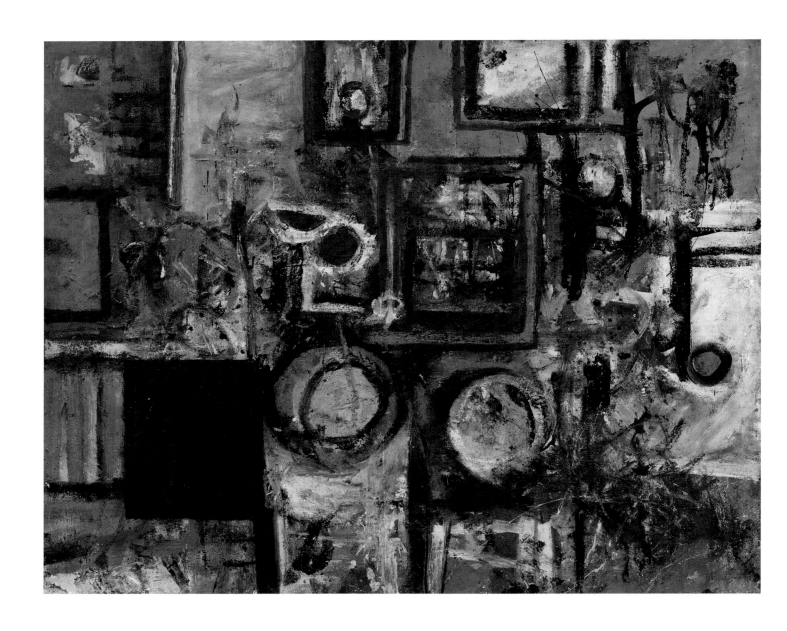

Alan Davie
Interior Exterior **1950**
Oil on hardboard
122 x 182.5 cm (48 x 71¾ in)
Wakefield Permanent Art Collection (The
Hepworth Wakefield) Purchased with funds
from the Contemporary Art Society, Wakefield
Corporation, Mr E. C. Gregor and Wakefield
Permanent Art Fund (Friends of Wakefield Art
Gallery and Museums) in 1958 from Gimpel
Fils, London.

Alan Davie
Marriage Feast or Creation of Man **1957**
Oil on canvas, triptych
213 x 366 cm (83¾ x 144 in),
complete work
Private Collection, Devon

after William Scott to exhibit in New York – with major paintings acquired by the Museum of Modern Art, New York, and esteemed collector Stanley Seeger – Davie's work had received little attention in Britain. As his gallerist Charles Gimpel wrote to Peggy Guggenheim, another early collector, 'Owing to the style and the enormous size of his work, it will take a long time before he finds recognition'.[2] For Davie, returning to England from America that year was a comedown, his triumph across the pond relatively unnoticed by the British art world.[3] This was to change in 1958 when, aged 38, Davie's first solo exhibition in a British public institution was held at Wakefield Art Gallery. Having grown its collection of 20th-century art during her tenure, Director Helen Kapp was earning a reputation for supporting contemporary artists. Her campaign to acquire Davie's *Interior Exterior* 1950 – the first painting by Davie to enter a British public collection – prompted Gimpel to champion the gallery as 'the only Museum of Modern Art in this country' and Bryan Robertson to proclaim, 'I think your action in assembling this show up north . . . is the most marvellous . . . inspiring action in the entire museum field since before the war'.[4]

To introduce Davie's work the exhibition's catalogue presented him as Britain's best-known action painter whose canvasses contain 'Pollock like streaks and splashes of colour'.[5] This characterisation stems from Davie's encounter with

modernist American painting, first during the early flourishing of the abstract expressionist movement in Europe, unveiled at the Greek Pavilion of the 1947 Venice Biennale, and later during his trip to New York in April 1956 where he met leading protagonists Jackson Pollock, Robert Motherwell, Mark Rothko and Willem de Kooning. As one of the first British artists to see and appreciate the zeitgeist of the New York School, Davie's emergence on both sides of the Atlantic during the 1950s saw him cast not only as the *enfant terrible* of British art but as its own Jackson Pollock. While Davie acknowledged his enthusiasm for the American painters and his and Pollock's shared interest in primitive art, he also expressed a wish to be discounted from abstract expressionism as the movement became articulated theoretically by critic Clement Greenberg, and when the work of the new American avant-garde appeared at London's Whitechapel Gallery. Writing later that year, Davie set forth to Greenberg that, 'Finally, having seen the art of America, I am now very much aware of being a European but – I no longer identify myself with the Americans in my "vision". I am working in quite another direction. Our visit has helped to "push" me, not in the direction of Pollock, De Kooning, Kline, but in my own way.'[6]

Kapp's exhibition in Wakefield was an expansive survey of Davie's work, featuring early figurative portraits, nudes and still lifes including *Self-Portrait No.2 (with Paint Brushes)* 1937 (p.14) and *Still Life with Guitar* 1939 that draw attention to the artist's technical confidence and wide-ranging awareness of early 20th-century visual culture. Having given up painting during his war service to focus

Alan Davie
***Still Life with Guitar* 1939**
Oil on canvas
43.2 x 91.4 cm (17 x 36 in)
Estate of Alan Davie

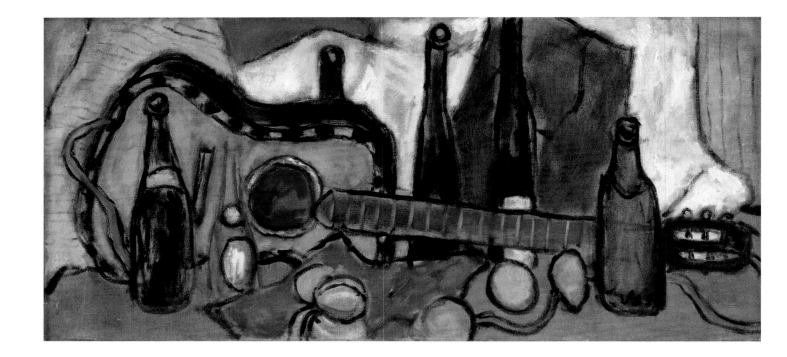

Alan Davie
The Saint **1948**
Oil on paper
122 x 89 cm (48 x 35 in)
National Galleries Scotland.
Purchased with the support
of the Heritage Lottery Fund
and the Art Fund 1997

on music and writing poetry, *The Saint* 1948 was painted in Venice towards the end of the artist's delayed trip around Europe on an art school travel scholarship. Its religious subject matter and colour suggest that Davie's close examination of Byzantine and early Renaissance art – captured in travel journals of the late 1940s – formed a vital part of his development. Having taken up painting again, while making a living selling jewellery and playing jazz, Davie set out on his return to

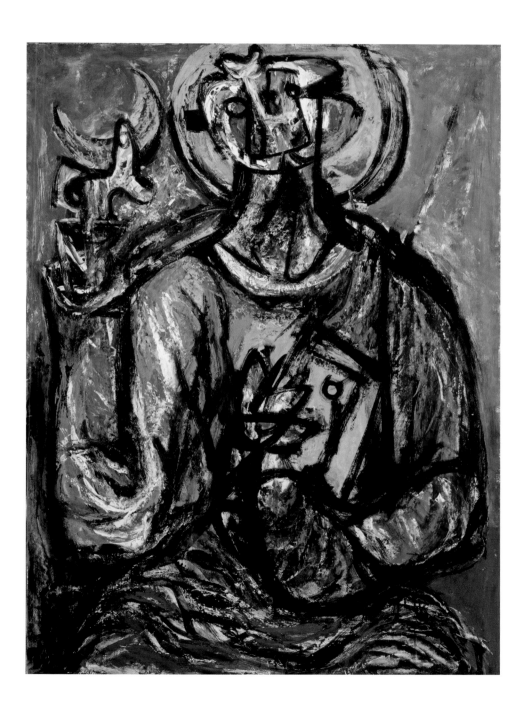

Britain to free himself from the conventions of picture-making. It was this radical breakthrough work of the early 1950s that attracted considerable attention in Wakefield. By that time, and as Lawrence Alloway had described in *Nine Abstract Artists* (1954), two dominant forms of abstraction had emerged in Britain – a pure geometric style exemplified by Victor Pasmore, Kenneth Martin and Mary Martin, and a painterly, more 'irrational' expressionism or tachism, in which artists, including Alan Davie, Terry Frost, William Scott and Roger Hilton, emphasised the process and materiality of painting. Rich in both gesture and iconography, *Ghost Creation* 1951 and *Blood Creation* 1952 are the result of Davie's highly improvisatory process, their biomorphic forms locked within layers of accumulated paint. Drawn to the violent, angry and deeply emotional aspects of these works, one exhibition review headlined 'An Irrational Painter' drew attention to their atmosphere of pagan ritual that, for Alan Bowness, represented 'a plunge back into a world of human and animal sacrifice, a primitive religion of darkness and appalling cruelty'.[7] In other works from this period, including *Interior Exterior* 1950 (p.16), Davie combined his improvisatory method of layering and obliterating forms with pictorial problems of

Alan Davie
***Blood Creation* 1952**
Oil on hardboard
183 x 183 cm (72 x 72 in)
The Ronnie Duncan Collection

Alan Davie
***Ghost Creation* 1951**
Oil on hardboard
152.4 x 122 cm (60 x 48 in)
Arts Council Collection,
Southbank Centre, London

space and depth. Suggestive of imaginary rooms with boxes and screens, these works were positioned by critic Robert Melville in relation to the fascination with science fiction of contemporary artists in the emerging Independent Group, and the sacrificial imagery of Francis Bacon.[8]

 Having set out to make paintings devoid of any visual reality, Davie began to realise he was instinctively creating symbols that opened up new and freer possibilities. As Melville described, while Davie's impulsive mark-making and gesticulatory brushwork remained at the forefront of the canvas, a greater element of illusionism transformed the otherwise shapeless gestures into things or beings determined by their shape:

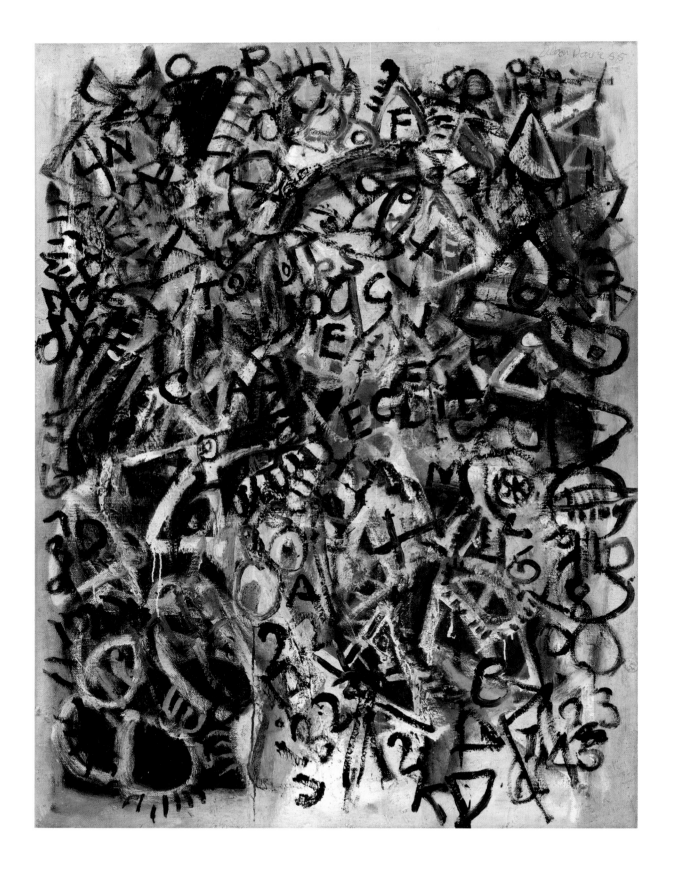

Opposite
Alan Davie
Bird Alphabet **1955**
Oil on board
123 x 91.4 cm (48½ x 36 in)
Estate of Alan Davie

Below
Alan Davie
Creation of Eve **1956**
Oil on canvas
175 x 244 cm (69 x 96 in)
Private Collection, London

Circles turn into wheels or breasts, sweeping curves tend to become worms or shapes, 'S' signs rear for striking or dip to avoid attack, 'C' signs snarl . . . the most innocuous mark loses its innocence and becomes capable of questionable conduct. A triangle will become anxious to assume the uses of a barb or a megaphone, a zigzag will pursue, a cross will lurk with intent, and a scrawl will appear to be as thoroughly meant as 'Down with the Bomb' or 'Jim loves Alice'.[9]

Davie's use of letters that cascade down the canvas in *Bird Alphabet* 1955 anticipate Robyn Denny's brutalist letter paintings, such as *Red Beat 6* 1958, exhibited at Gimpel Fils gallery that year, and Gwyther Irwin's superfluity of letters and messages in his collage *Letter Rain* 1959. Others exude biological content as Davie began to describe the primal, almost sexual, forces at play in his creative process. In *Creation of Eve* 1956, described by Davie as 'a magical

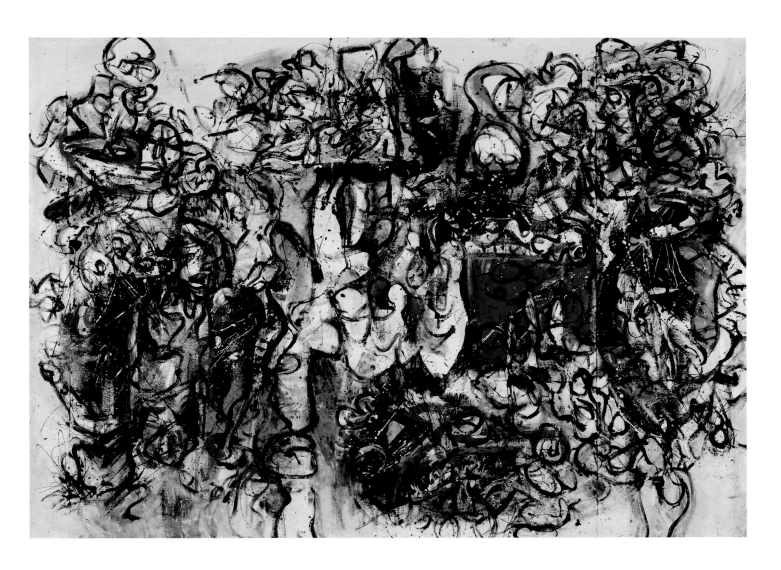

creation of a woman from NON MATTER',[10] bodily forms and handprints emerge from a cornucopia of gnarly gestures. In *Anthropomorphic Figures no.1* 1958, two central swirling black figures that are part human, part animal are divided by a red line that rips through the bottom half of the canvas. Having been labelled a libidinous artist, whose potent signs and symbols exult in the orgiastic aspects of human behaviour, a series of rarely exhibited erotic drawings of couples in passionate, aggressive sexual embraces show how spontaneous drawing relating to these paintings allowed Davie even greater freedom to express his desires.

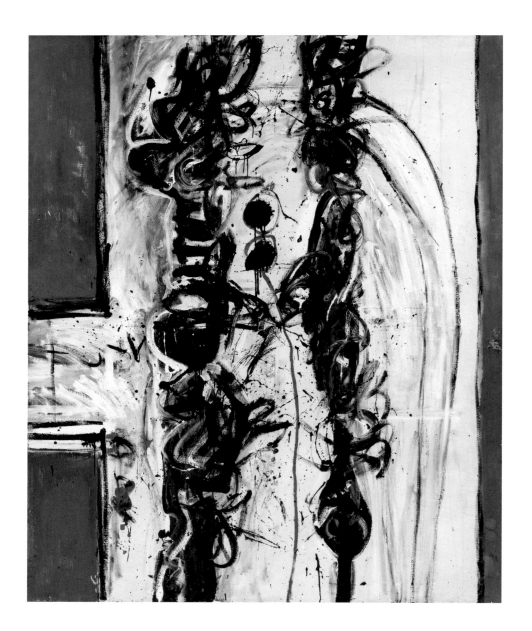

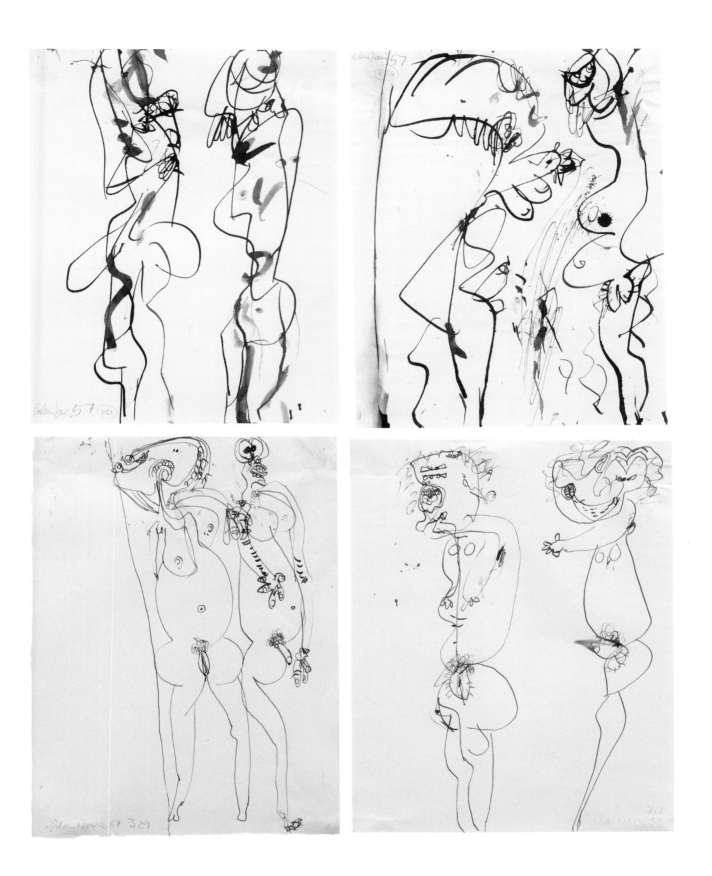

In 1956 Davie was awarded a prestigious Gregory Fellowship, an initiative inaugurated by Peter Gregory in 1950 at the University of Leeds to provide promising artists a space and secure income to make work. For Davie, the fellowship brought him into closer contact with a lively community of artists, writers and scientists and a wider public. In his lecture 'The Artist and the Physicist: An Exchange', given to the university's Physics Society, Davie articulated his ideas about the relationship between artist and scientist in the age of Sputnik and Zeta, and the futility of their search for truth and reality. 'Simultaneously, as science has departed from perceptual reality, art has come to be concerned with a kind of activity which is far removed from the materialist way of thinking. In his search for truth, the painter, like the scientist, has adopted unrealistic and abstract techniques and symbols. And yet the ultimate truth forever remains just outside his reach.'[11] Rather than being frustrated, Davie expressed an appreciation of the poetics involved in the ungraspable nature of reality. In a statement in the 1958 Wakefield catalogue he reflected, 'Knowing that life is so strange and so uncontrollable, there is no way, and art is impossible, as impossible as living. And yet one lives, and strange things happen, and Art also happens, like falling in love.'[12]

A young contemporary

Having revived interest in Davie and his 'forgotten generation', Helen Kapp's letters reveal that people travelled considerable distances to see the Wakefield exhibition: 'It is unlike anything that he [Davie] has had before', she wrote, 'and he will now, for the first time, be known in far wider areas and will have gained a very considerable new public'.[13] One of the attendees for whom the exhibition was to have a powerful impact was David Hockney. Having graduated from Bradford School of Art the year before, Hockney was part way through his two years working for the National Health Service as a conscientious objector. Like Davie before the war, Hockney had received little exposure to modern art; his contemporary Peter Phillips noting, 'At this particular time, if you were a guy from a provincial town, one had very little contact with any sort of painting.'[14] In numerous biographies, Hockney recalls that his training at Bradford School of Art was traditional, the National Diploma of Design producing a rigid style where colour was largely ignored and freedom to paint with expression denied. As such, Hockney's work from this period, characterised by a series of sombre landscapes and portraits painted in the style of the Euston Road school, reflects the students' encouragement to go out and observe the world. In fact, Hockney's painting tutors proved to be important conduits to the latest developments in contemporary art. Frank Lisle, who also worked at Leeds College of Art, and Derek Stafford, a graduate of London's Royal College of Art (RCA), who represented 'southern sophistication' among the students, invited other tutors and artists to talk to the students and arranged trips to Edinburgh, London, Leeds and Wakefield to see the galleries and museums.[15]

David Hockney
***Bradford Market Scene* c.1955**
Watercolour and ink on paper
64 x 53 cm (24¼ x 20¾ in)
Collection Bradford Museums
& Galleries, Bradford, UK

Several sources suggest Hockney met Davie in Wakefield.[16] This was likely to have been during one of the numerous talks Davie gave to students as a Gregory Fellow or occasions when he made himself available to answer questions from the public in the galleries. 'We are having an average of up to 120 people a day here, which of course is very thrilling for us', reported Helen Kapp: 'On the Saturday that Davie came to talk about his pictures, 485 people turned up – it was like a football scrum'.[17] Having had a rare opportunity to see the work of a living artist in the flesh rather than in reproduction, as was usually the case for art students, Hockney quickly became seduced by Davie's art that represented a radical alternative to the grey parochialism of much British art of the 1950s.[18] As Marco Livingstone writes, 'A painting, [Hockney] now recognised, need not be a passive receiver of information about the visible world, but may adapt a far more aggressive role in providing the actual impetus to the viewer's experience'.[19] Cited as the first experience to jolt him out of provincial art-school thinking, Hockney's sense of emancipation from the kind of art he had been taught to make was enhanced by the fact that Davie was working in nearby Leeds, making it all the more real and

immediate.[20] Inspired to become a modern artist, in September 1959 Hockney moved to London to take up a place at the RCA.

> Immediately after I started at the Royal College, I realised that there were two groups of students there: a traditional group who simply carried on as they had done at art school, doing still life, life painting and figure compositions; and then what I thought of as the more adventurous lively students, the brightest ones, who were more involved in the art of their time. They were doing big abstract expressionist paintings on hardboard.[21]

Of the latter, Hockney was likely referencing Peter Phillips and Derek Boshier. 'Most people were doing a lot of still lifes, a lot of head portraits, rather out of the tradition of what the staff painted' recalled Boshier, whose seldom-seen early painting *Untitled Still Life* c.1958–9 evokes Davie's Scottish contemporary William Scott's abstracted tabletop still lifes of the early 1950s. For Boshier, Davie was a unique painter 'with symbols – orbs and stuff like that. He was quite a big influence, influence on me for instance. After seeing his paintings, I did a lot of paintings that led to Airmail Letter [*Airmail* 1961] . . . they looked very formal, but they were at that stage "pop" as it were . . .'[22] While Phillips would maintain he was not influenced 'by the English abstract thing', his transition from social realism to colourful paintings in which abstracted and figurative images hover alongside each other is evident in *Bingo* 1960, whose subject of play would become a preoccupation for a number of artists including Davie and Hockney who featured references to card games in their collages and paintings of the 1950s and 1960s.[23]

At the end of his first year Hockney embarked on a series of abstract pictures on small boards provided by the college. 'Young students had realised', he said, 'that American painting was more interesting than French painting . . . American abstract expressionism was the great influence. So I tried my hand at it. I did a few pictures . . . that were based on a kind of mixture of Alan Davie cum Jackson Pollock, cum Roger Hilton'.[24] Having missed the Tate Gallery's *New American Painting* exhibition of 1959, Hockney took the predominant abstract style of his British predecessors as his model of Modernism, with characteristic colours and shapes from their work appearing in a number of his paintings. With its palette of ochre yellows, delineated black lines and phallic shapes, *Erection* c.1959 (pp 2 and 31) is one of the first works evoking through its titling the themes of identity and sexuality that would become a primary concern.

Hockney would always maintain that his images from this period only emerged during the course of the painting and were not preconceived. Yet, troubled by their lack of content, he began to incorporate words into his paintings, a feature he claimed enabled him to remain modern while making his pictures more interesting and with clearer meaning. Having learnt from Davie how the emergence of symbols and text allowed a figurative interest to remain under the surface, the splashy and scrawled earthy forms set against the white ground in

The First Love Painting 1960 correspond to those in Davie's *Glory* 1957. Included in Davie's Wakefield exhibition, this painting is an early example of Davie's use of handwritten text. Like Davie, Hockney also included the title of his picture written like graffiti. As Derek Boshier observes: 'David saw a way of introducing things the way Alan Davie was doing, but instead of symbols, David used graffiti. The secret life of David started to come out with graffiti . . . all the love messages that he coded into letters, you can read them in the paintings.'[25] Here, the word 'love' and other calligraphic letters and words obscured under layers of paint insist on the individuality of the artist's hand and on the construction of a pictorial message that can be read by the viewer without conforming to the conventions of figuration

David Hockney
***The First Love Painting* 1960**
Oil on canvas
102.2 x 128.3 cm (40¼ x 50½ in)
Private Collection

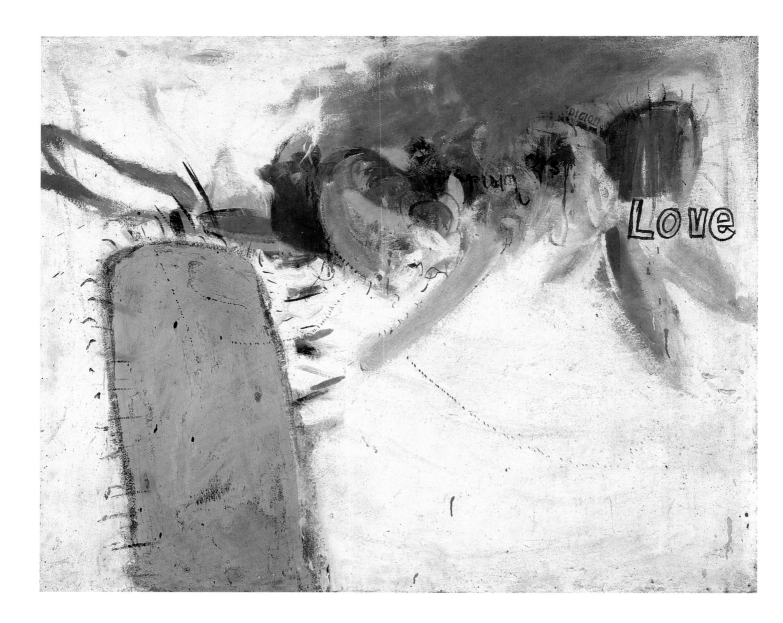

Alan Davie
Glory **1957**
Oil on canvas
172.7 x 213.3 cm (68 x 84 in)
Private Collection

and illusionism. Marco Livingstone describes Hockney's words as having two functions, that of transmitting the message – a basic goal of the modern artist – and that of making the viewer aware of the material composition of image as paint on canvas: 'If one stands close enough to these pictures to read the messages, it is possible to lose sight of the images as they seem to disappear into the deliberately rough surfaces of paint, so that one's consciousness of the tactile qualities of the manipulated paint is increased'.[26] Yet the clearly delineated forms of the word 'love' that anticipate the Letraset titles of later works also suggest something impersonal and anonymous with which to reference personal acts and feelings. Having become alert to how words and titles condition perception and understanding of paintings,

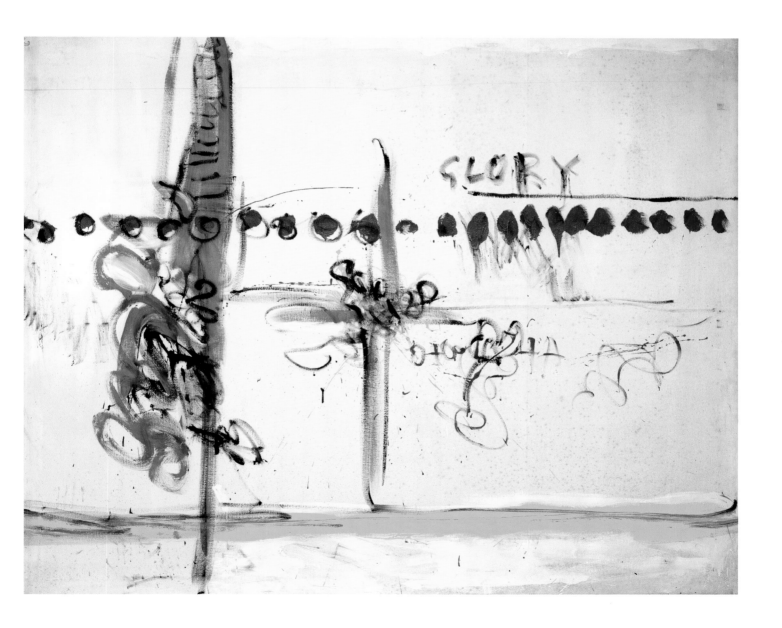

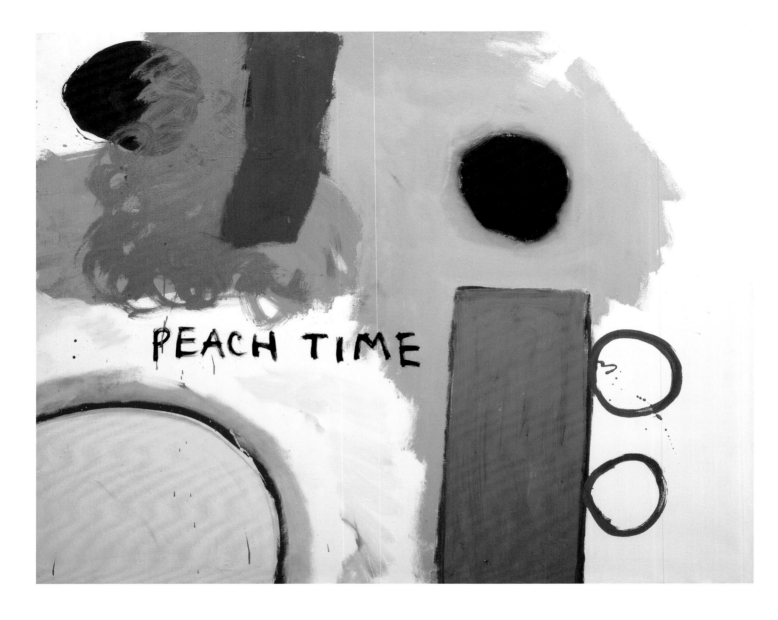

text would become an important device for Hockney throughout the 1960s as his work became increasingly figurative. With descriptive words making a revival in Davie's paintings of the early 1960s – most vibrantly in *Peach Time* 1961 and *Mango Time* 1961 (p.89) – it has been suggested this may have been on account of the widespread interest in Hockney's work from this time.[27]

Having read Walt Whitman's *Leaves of Grass* in the summer of 1960, Hockney would, as Davie had after consuming it in his army bunk, decide that poetry was a worthy subject for his art. While Davie had taken Whitman's love of nature and free prose as a stimulus for his own experimental writing, jazz playing and image-making, for Hockney Whitman represented a liberated figure, whose depiction of homosexuality and portrayal of love between men became a crucial

Alan Davie
***Peach Time* 1961**
Oil on canvas
122 x 152.4 cm (48 x 60 in)
Richard and Susie Coles

David Hockney
Adhesiveness **1960**
Oil on canvas
128.3 x 102.2 cm (50½ x 40¼ in)
Modern Art Museum of Fort Worth,
Texas

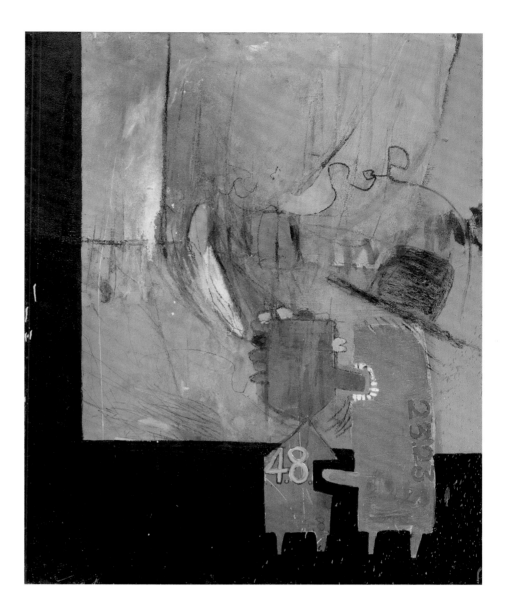

motivation for his series of love paintings exploring male desire through the relationship between two figures. In *Adhesiveness* 1960, which Hockney refers to as his first serious painting,[28] the artist's admiration for Whitman is expressed by adopting as its title the poet's phrase for a close, loving friendship. Here, two figures, identified by their coded numbers as D.H., W.W. and C.R. (David Hockney, Walt Whitman and Cliff Richard),[29] can be seen enjoying mutual fellatio; the teeth of the right figure reminiscent of Davie's aggressive sexual drawings. The background is divided with thick dark bands across the side and bottom, leaving the rest open to lines, shapes, marks, drips, squiggles and scribbles. This framing device, which emphasises the overall flatness of the image but places the figures within a suggestion of recessive space, can also be seen in

a number of paintings Davie exhibited in Wakefield, such as *Bubble Figure no.2* 1954. Hockney sometimes used these backdrops to suggest public walls covered in graffiti. While, in *Adhesiveness,* the scrawls on the back 'wall' are illegible, in *We Two Boys Together Clinging* 1961 (p.64), two crude bodies in the style of Jean Dubuffet (whose work was becoming well known on the English scene) embrace, surrounded by valentine hearts, coded numbers and broken words and phrases. As in *Composition (Thrust)* 1962, in which a Dubuffet-like figure is accompanied by the words 'queen' and 'thrust', these form a textural effect akin to graffiti

Alan Davie
Bubble Figure no.2 1954
Oil on Masonite
133.5 x 99 cm (52½ x 39 in)
Private Collection, UK

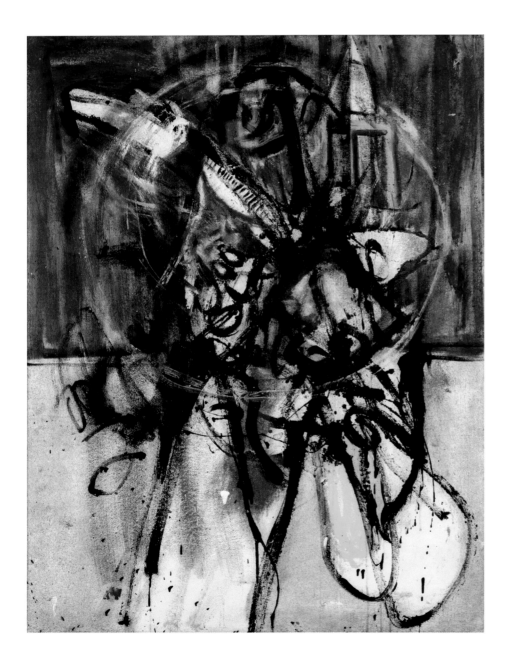

David Hockney
Composition (Thrust) **1962**
Mixed media on board
118.1 x 88.9 cm (46½ x 35 in)
Royal College of Art

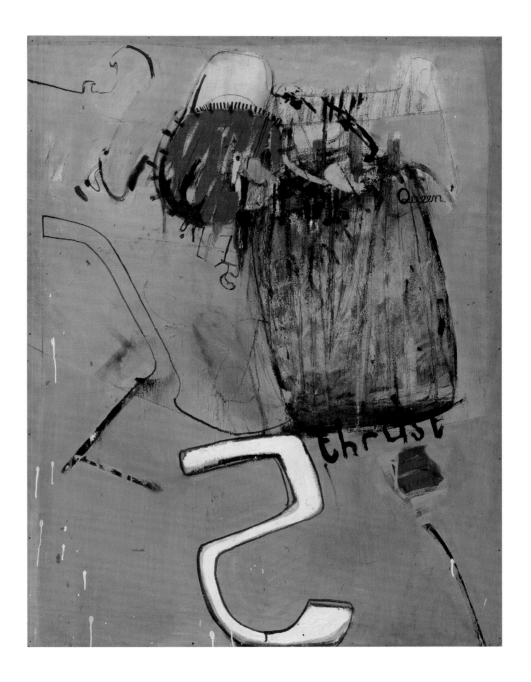

where messages are hastily written, some partially obscured or rubbed out. For the theorist Anton Ehrenzweig, the use of such graffiti, 'inspired by the strongest human desire towards an object, sexual love', formed a new syncretism in art after the decline of Modernism.[30] The inclusion of graffiti led Hockney to be grouped with the emergent pop art movement, yet, as David Sylvester swiftly established, his highly personal use of graffiti was at odds with the more technologically advanced and mass-mediated forms of communication of his pop peers.[31]

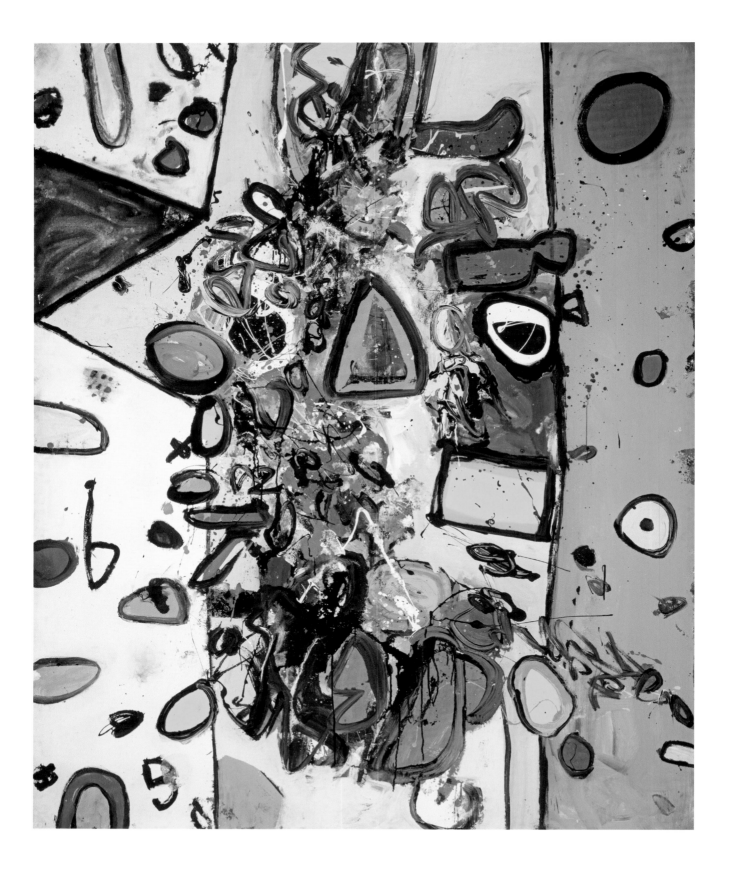

A symbolism for the modern age

Throughout the 1960s, as Davie's paintings developed with greater conceptualism, spatial complexity and more prominent use of figuration and text, literature on his work became driven by esoteric and transcendental readings of his imagery. As a result, Davie has been positioned as a mercurial, shamanic figure untouched by external forces, his role as an important agent in the wider cultural field of the 1950s and 1960s obscured. Yet, by 1960, Davie's ideas were well tuned to the growing concerns of the new generation about the potential of abstraction: 'At present there appears to exist a great gulf between abstract art and representation', he observed, 'This must be bridged, and a true unity achieved'.[32]

Cutting through the standard periodisation of post-war British art that separates the 1950s from the Swinging Sixties, the appearance of Davie's writing in Michael Horovitz's British beat poetry magazine *New Departures* brings him into sharper focus with the counter-cultural movement of the early 1960s, whose activity ran alongside the ebullience of abstraction and pop.[33] *Lush Life no.1* 1961 signals a shift from Davie's pastel backdrops of the previous decade to an increasingly colourful and graphic repertoire in which a joyful interplay of bright, simple shapes with flatter blocks of unmixed colour and different handling of space announce the new freedom and liberation of the era. This is perhaps foreshadowed in a series of collages made in the 1950s, using fragments of adverts and newspapers. When asked about the radical shift that was taking place

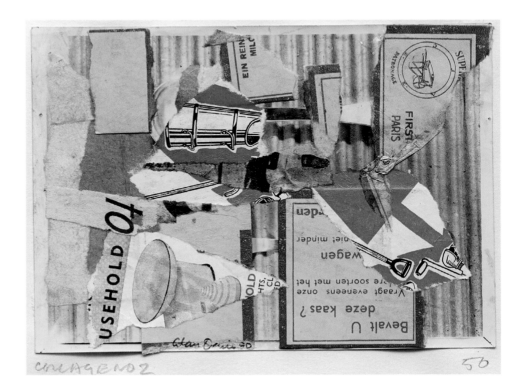

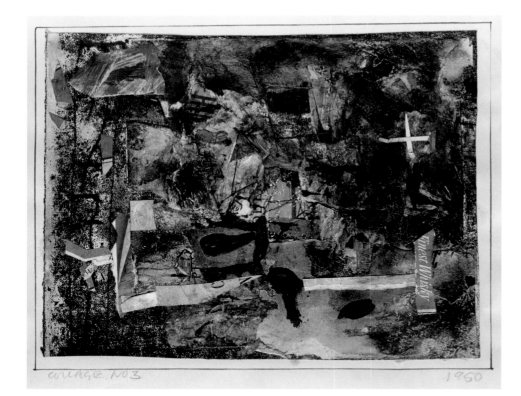

Above
Alan Davie
Collage no.3 **1950**
Collage
Sheet: 30 x 25.3 cm (11¾ x 10 in)
Image: 15.2 x 19.4 cm (6 x 7¾ in)
Private Collection, Devon

Below
Alan Davie
Collage no.5 **1950**
Collage
Sheet: 23.5 x 22.5 cm (9¼ x 8¾ in)
Image: 12.5 x 16 cm (5 x 6¼ in)
Private Collection, Devon

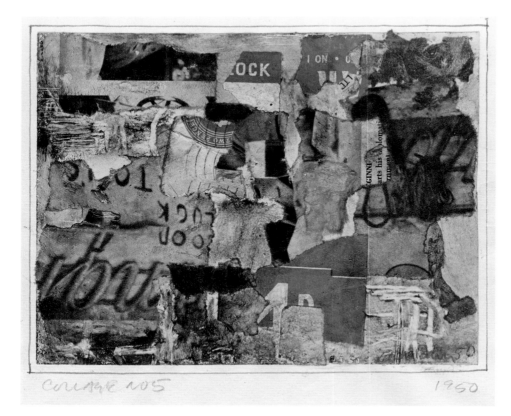

in art towards more direct references to the real world, Davie maintained he had no interest in pop art, declaring it 'a decadent phase'. But, as he revealed, 'I've always had a great love of toys . . . I've always loved things like doll's houses and little miniature things. That kind of fascination which I suppose has some contact with the Pop artists.'[34] This interest, which Davie traces in relation to the work of his friend Eduardo Paolozzi, became the subject of a series of paintings taking the title 'dolly'. A recurring red and pink figure, the focus of a series of five Dollygod paintings including *Dollygod no.3* 1960 (p.42), implies the then fashionable reference for an attractive girl and the avant-garde baby doll dress synonymous with sexual freedom. Having seen the controversial 1956 film *Baby Doll* starring Carroll Baker, Hockney embarked on his own series based on this cultural phenomenon in which fantasies and boyfriends begin to appear as principal figures. Chiefly among these, the subject of *Doll Boy* 1960 (see p.43), is Cliff Richard, whose single 'Living Doll' had been a hit the previous year.

It is largely overlooked that Davie's work was included alongside that of the British abstract painter Ian Stephenson in the iconic British film of the period, *Blow-Up* 1966. The film's director, Michelangelo Antonioni, shared Davie's commitment to creative intuition and improvisation, and filmed the artist working in his studio during the preparation of the movie before borrowing *Joy Stick Stick Joy* 1960. With the plot based around hard-to-decipher surfaces, the main protagonist believes he has photographed a murder, only to discover that his blow ups revealed ambiguous, granular images. Seen as an icon of 'Swinging London', the film's questioning of perception and reality is underpinned by the spirit of Davie's metaphysical paintings that serve as a reminder of the futility of searching for rational truth in images. As Antonioni reflected: 'We know that underneath the displayed image there is another one more faithful to reality, and underneath this second there is a third one, and a fourth under the previous one. All the way to the true image of that reality – absolute, mysterious – that nobody will see. Or all the way to the dissolution of any reality.'[35]

Content and form

Hockney's next body of paintings were also concerned with questions of reality and illusion. Keen to distance himself from the Pop label, in the 1962 *Young Contemporaries* exhibition he showed four paintings under the title 'Demonstrations of Versatility' to critique conventions of artistic expression. As he described in an interview with Larry Rivers: 'I deliberately set out to prove I could do four entirely different sorts of picture, like Picasso. They all had a subtitle and each was in a different style, Egyptian, illusionistic, flat, but looking at them later I realized the attitude is basically the same and you come to see yourself a bit.'[36] For the largest of these, *A Grand Procession of Dignitaries in the Semi-Egyptian Style* 1961 (p.44), Hockney studied the flatness as well as the combination of figures and hieroglyphics in Egyptian wall paintings. With Davie's jewellery having

Alan Davie
Dollygod no.3 **1960**
Oil on Masonite
121.9 x 152.4 cm (48 x 60 in)
Private Collection, Devon

David Hockney
Study for Doll Boy (no.2)
1960
Oil on board
76.2 x 50.8 cm (30 x 20 in)
Private Collection

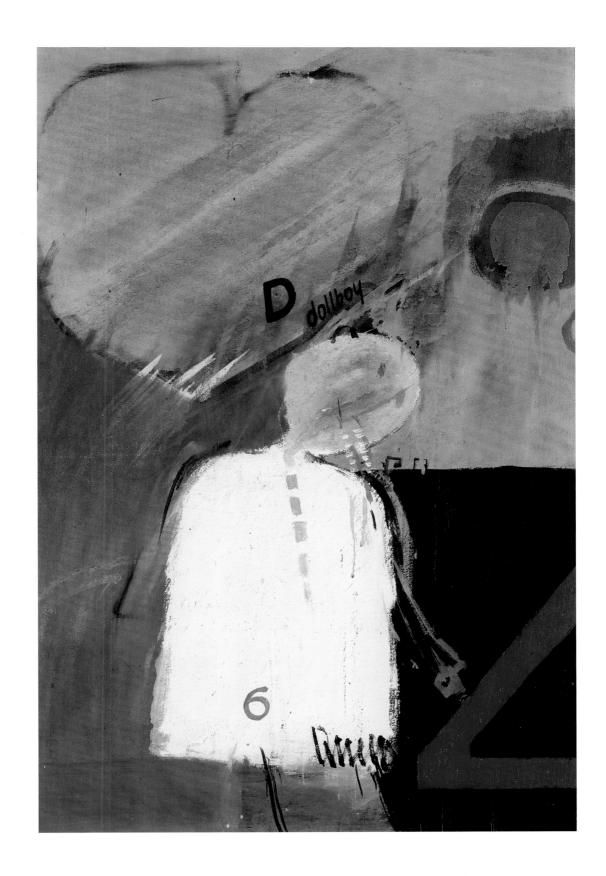

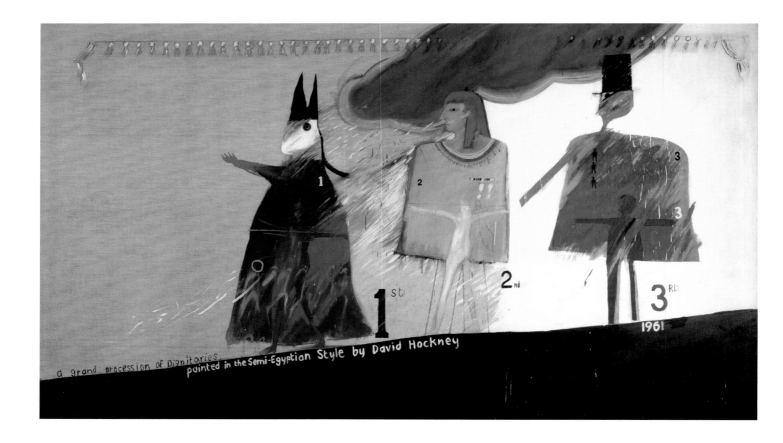

A Grand Procession of Dignitaries painted in the Semi-Egyptian Style by David Hockney

been worn by Vivien Leigh in the 1951 stage production of *Caesar and Cleopatra*, a role revived by Elizabeth Taylor in the 1963 film *Cleopatra*, and the ICA's 1962 exhibition *5,000 Years of Egyptian Art*, Hockney's appropriation coincided with a moment of popular fascination with Egypt. *Egyptian Head Disappearing into Descending Clouds* 1961 imitates the formal figure style of Egyptian art and presents an inanimate, stylised Egyptian head in profile engulfed by an ambiguous cloud that disrupts the flatness of the image, while *Man in a Museum (You're in the Wrong Movie)* 1962 (p.46) combines an Egyptian figure – a statue seen in the Pergamon Museum in Berlin – with the figure of a man in contemporary dress on a black 'ground', an incongruous juxtaposition that again celebrates flatness within the picture plane. Davie also referenced Egyptian art at this time in his painting, featuring motifs including eyes, serpents, fish and ankhs, the Egyptian symbol of life, as seen in *Cross for the White Birds* 1965 (p.47), on increasingly sparse and 'flat' grounds, reaffirming his ideas about the potential for symbols to reveal universally accessible meaning.

David Hockney
A Grand Procession of Dignitaries in the Semi-Egyptian Style **1961**
Oil on canvas
213.4 x 365.7 cm (84 x 144 in)
Private Collection

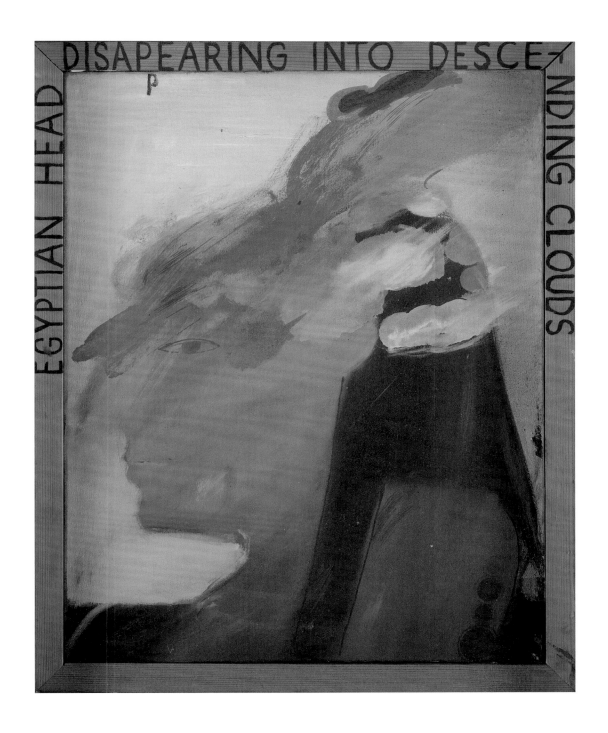

David Hockney
Egyptian Head Disappearing
into Descending Clouds **1961**
Oil on canvas
50.2 x 40 cm (19¾ x 15¾ in)
York Art Gallery (York Museums Trust)

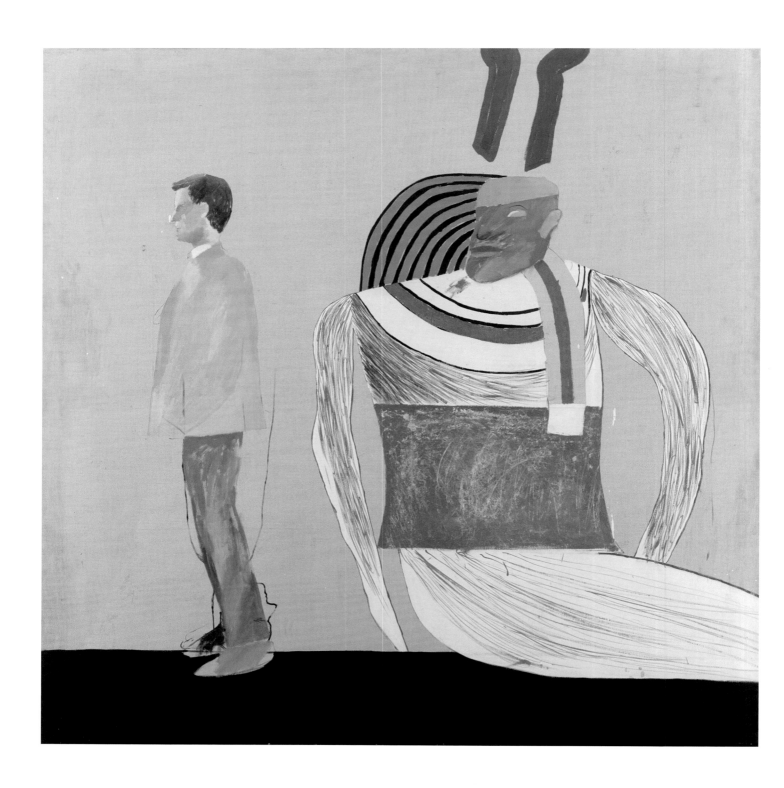

Opposite
David Hockney
Man in a Museum (You're in the Wrong Movie) **1962**
Oil on canvas
147.3 X 152.4 cm (58 x 60 in)
British Council Collection

Below
Alan Davie
Cross for the White Birds **1965**
Oil on canvas
152 x 74 cm (60 x 29¼ in)
Wakefield Permanent Art Collection
(The Hepworth Wakefield). Presented
by Sir Alan Bowness through the Art
Fund, 2008

Hockney further developed these ideas as he began to blend an interest in civilisations of the past with the styles of his near contemporaries. Painted after his first visit to the West Coast, *Arizona* 1964 and *Rocky Mountains and Tired Indians* 1965 are highly theatrical landscapes combining simplified and fragmented natural forms and stylised figures – the latter drawn, as Hockney recalls, from 'geological magazines'.[37] In describing the earlier *Flight into Italy – Swiss Landscape* 1962, that included a postcard photograph of the Alps, Henry Geldzahler notes Hockney's interest in 'juxtaposing many kinds of information on a flat surface: a mountain range in rainbow-like stripes quoted from contemporary abstraction; the clearly-lettered sign "Paris" contrasted with the speedy blurring of "that's Switzerland that was" (a reference to a Shell advertisement then current)'.[38] As in Davie's *Crazy Gondolier* 1960 (p.50), dominated by a vibrant rainbow form, the diagrammatic circles and arcs that appear in Hockney's paintings are deliberate references to post-painterly abstraction, most notably the target-like circular forms in the paintings of Kenneth Noland and the rainbow-like stripes of pure colour of Morris Louis, whose work was regularly shown in the early 1960s in London by Hockney's gallerist John Kasmin.

Below
David Hockney
***Rocky Mountains and Tired Indians* 1965**
Acrylic on canvas
170.4 x 252.8 cm (67 x 99½ in)
National Galleries Scotland.
Purchased 1976.

Opposite
David Hockney
***Arizona* 1964**
Acrylic paint on canvas
153 x 153 cm (60¼ x 60¼ in)
Private Collection

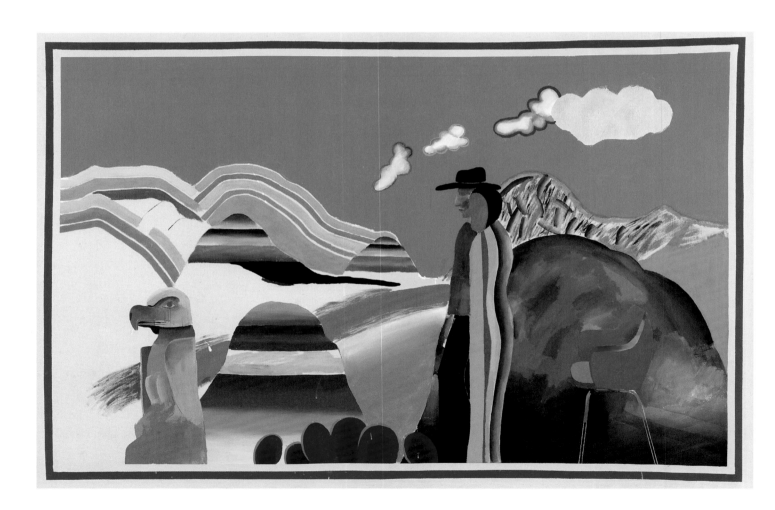

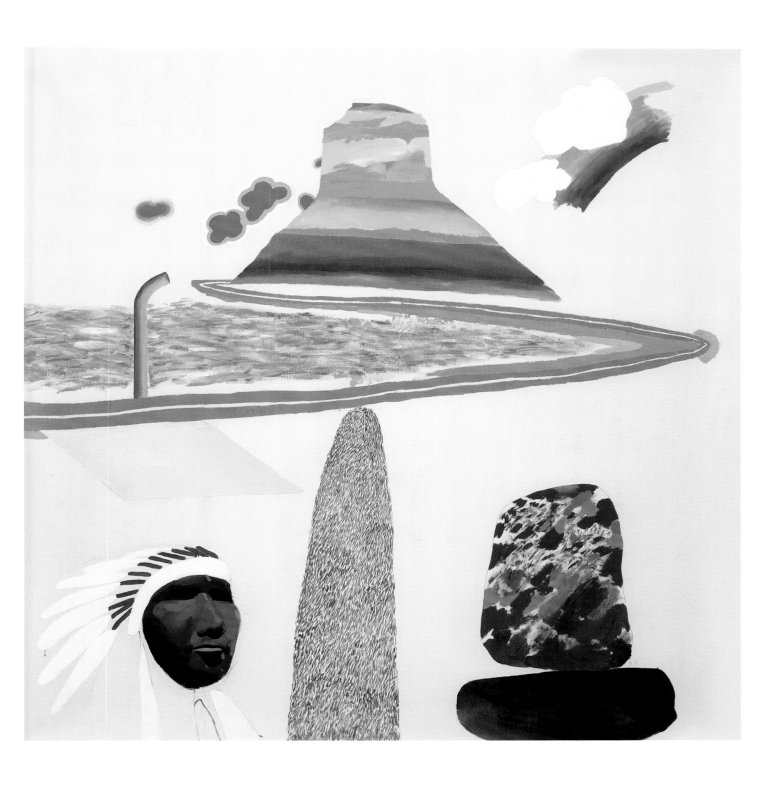

Above
Alan Davie
***Crazy Gondolier* 1960**
Oil on canvas
183 x 244.2 cm (72 x 96¼ in)
National Museum Wales

Opposite
David Hockney
***Flight into Italy – Swiss Landscape*
1962**
Oil on canvas
184 x 185 cm (72½ x 72¾ in)
Kunstpalast, Dusseldorf

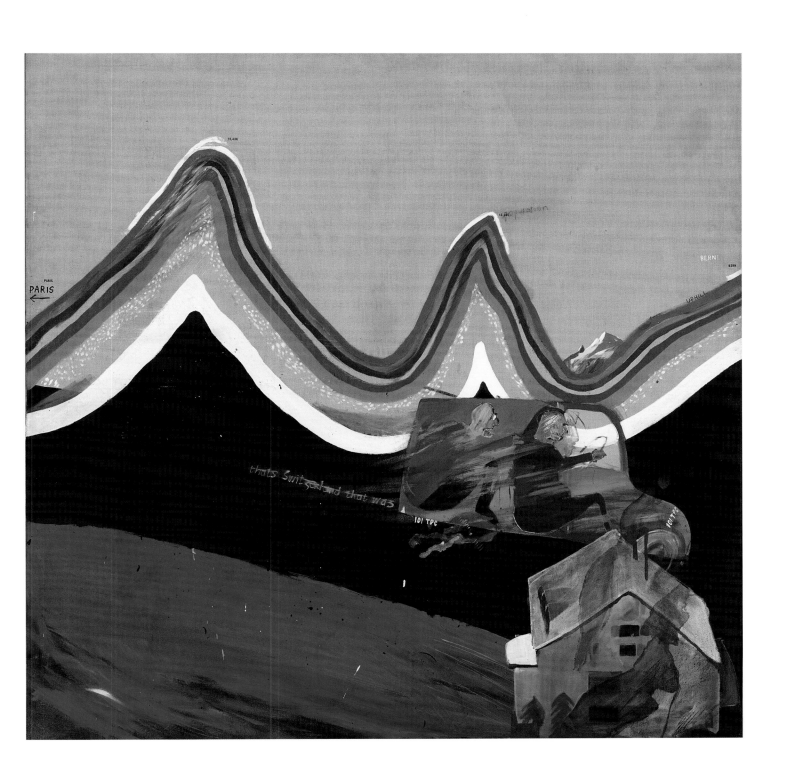

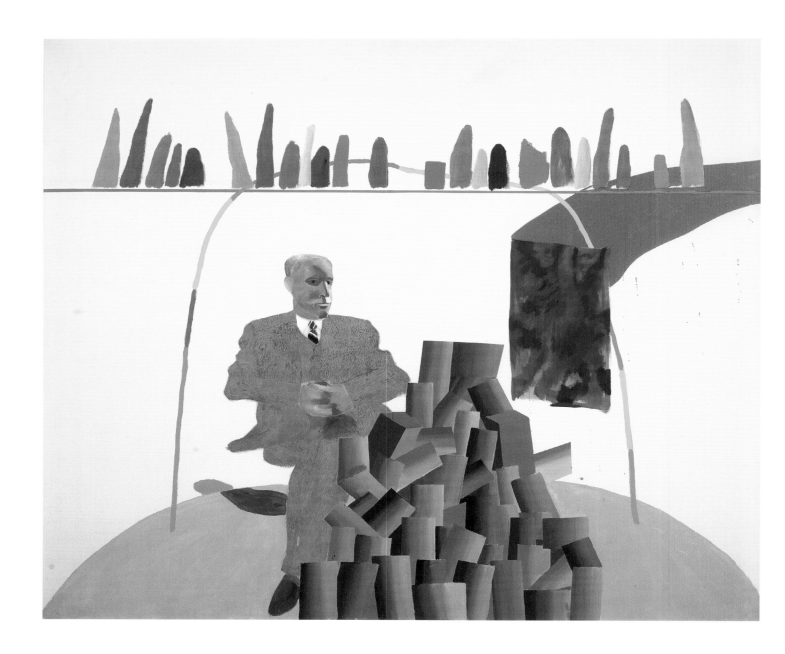

Widely considered to be Hockney's manifesto on modernist painting, these technical exercises culminate in *Portrait Surrounded by Artistic Devices* 1965. Exemplifying Hockney's desire to resolve the division between abstraction and figuration, the juxtaposition of the artist's portrait of his father surrounded by different artistic devices and styles of painting are claimed to represent his growing concern about modernism's privilege of theory over human content. Having experimented, through Davie, with abstraction to reveal its figurative potential, Hockney would declare that lived experience and observation, rather than imagination, would become the principal basis for his painting.

David Hockney
Portrait Surrounded by
***Artistic Devices* 1965**
Acrylic on canvas
152.4 x 182.9 cm (60 x 72 in)
Arts Council Collection,
Southbank Centre, London

Art and the self

As the mythology of Swinging London gained currency, the new promotional culture and concern for the everyday brought a shift in public interest in art, with artists becoming subject to the kind of treatment reserved for personalities in the entertainment and fashion industries.[39] Alert to this new public arena, Davie and Hockney were active in the resolute self-fashioning employed by many cultural figures of the period. Yet, as their media presence during this period reveals, neither conform to the cliché that 'Your modern painter is no longer a man with sandy hair and a fisherman's sweater, perched on the Cornish rocks, now he is leather jacketed and lives in a city which shares, more or less, visual and mass cultural patterns with the big American cities', preferring to carve out their own mythologies and tropes of masculinity.[40]

Having previously presented himself as a brooding romantic and wistful poet, posing like his literary hero Walt Whitman in photographs prefacing his books of wartime poetry, Ida Kar's portrait of Davie, commissioned for the catalogue of his Whitechapel exhibition in 1959, presents the artist as the quintessential 1950s bohemian. Yet the intensity of Davie's pose, devoid of any signs of his profession, contrasts with those of his St Ives contemporaries,

who Kar photographed at work in their studios for her 1961 *Tatler* feature 'Le Quartier St Ives'.[41] Images of Davie in the 1960s recast the artist as a symbol of modern masculinity, leading Allen Jones to profess that '. . . for more than one generation of students, Davie was the Man, the Myth'.[42] The liberation of Davie's body and his appearance as a physically potent artist is revealed in a super-8 film shot by the artist's wife, Bili Davie, in 1961 – the same year action painting was parodied by the actor Tony Hancock in the satirical comedy *The Rebel*. Presented as an athletic performer moving agilely and seamlessly between several large canvases, here the macho Davie, stripped to the waist, bears an uncanny resemblance to the heroic Pollock, whose process of dripping and pouring paint directly onto the canvas was famously captured in the early 1950s by filmmaker Hans Namuth.[43] Likewise, in one of David Sylvester's early articles for the new *Sunday Times* colour supplement, Davie represented the 'Cult of Painting Big', with images of his colourful home furnished with state-of-the-art Arne Jacobsen egg chairs a marker of his potency and appeal to fashion-conscious readers. 'Painting big means painting with man-sized gestures, putting it on with a swing and no cramping of one's style', it read.[44]

Conversely, Jorge Lewinski's portraits model Davie as an introspected spiritual guru, reflecting one eyewitness's conviction that Davie had developed an 'act' for his infrequent public appearances, choosing to appear before us as the good Zen man, smiling and relaxed.[45] An important aspect of Davie's practice at this time was gliding, an activity he took up in 1960 and shared on many occasions with his friend, the artist Peter Lanyon: 'Davie has joined me gliding', Lanyon wrote to Robert Motherwell, 'and ascends like Jesus into the clouds'.[46] Photographs of Davie perched upon his glider or posing by his sleek Jaguar E-type presented the artist as a daring and transgressive modern. Attributing his collaboration with the elements through the act of letting go and the intuitive revelations in his painting, Davie's pursuit of fast cars, scuba diving and sailing also forms part of the optimistic, fast-living, risk-taking persona captured by the fashion photographer John Cowen, who shot a royal marine frogman diving into action for his feature 'Everyday, Danger' for *Queen* magazine in December 1959, and the British fashion model Jill Kennington parachuting for the feature 'Birds in Space' in *The Sunday Times*, June 1963.

For a number of art historians, including David Mellor, the promotional fashioning of Hockney was one of the key events of the early 1960s, with numerous accounts of how his body quickly became synonymous with the body of fame and then disembodied as a media legend.[47] Like Davie, Hockney also maintained a self-consciously different appearance from his peers, adopting Stanley Spencer's eccentric pudding bowl haircut as a teenager and then a crew cut and boiler suit that contrasted with the sleek Italian style of his Royal College of Art peers. During this period, Hockney quickly exploited the new publicity machinery, presenting himself as a pop star-like figure in shoots by leading photographers of the day – Lord Snowdon, Cecil Beaton and David Bailey – and regularly appearing in glossy fashion magazines. In his first published profile, in

Opposite
David Ware
Alan Davie with E-type Jaguar and glider c.1965

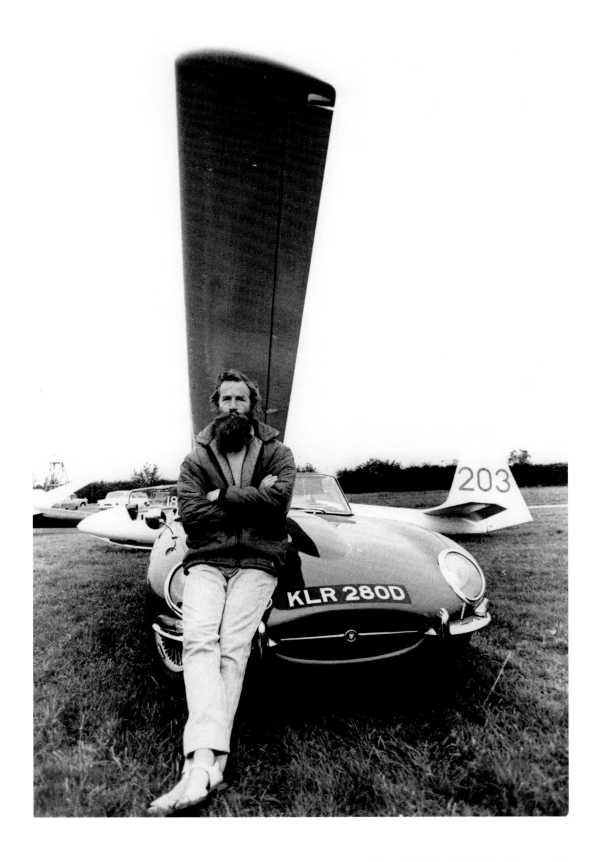

Queen magazine in February 1962, Hockney was photographed with his painting *A Grand Procession of Dignitaries in the Semi-Egyptian Style* 1961 but appeared as a blurred figure in the corner of the image, his description as an 'emergent blur' said to indicate the speed of his success.[48] Coincidentally or not, Davie's 1961 painting *The Blond Goes Gay* recalls the attention surrounding Hockney's decision to dye his hair blonde during his first visit to New York in 1961. This gesture, which became the main element of Hockney's persona as well as a new form of display contrary to traditional masculine identities, was indicative of the artist's desire to be noticed both as an artist and person. With his personality and image becoming increasingly separate from his art, reviews of Hockney's early work were often accompanied by exploitative references to his colourful persona that led to suggestions his art lacked depth. His appearance in *Town* magazine in September 1962, in which Hockney was photographed with his peroxide hair in a working man's vest, encapsulates the paradox of the artist's sexuality and northern working-class background and the era's characterisation of industrial northern manliness.[49]

Having warned of the pitfalls of exploitation and overexposure of artists during this period, for Bryan Roberston Hockney's future success remained open to question, as it did in *Tatler* magazine that year when they asked 'Will success spoil David Hockney?'[50] Nevertheless, Hockney's inclusion in John Russell, Bryan Robertson and Lord Snowdon's totemic *Private View: The Lively World of British Art* – which also featured Davie – as a 'hero figure for his generation' confirmed his position in the British art world.[51] Having reported a widening crack between the established middle generation of artists and the young, the 1962 article 'A Boom for the British' believed 'the high spirits of the new generation appear more rootless and wilder than they would if they were seen beside their origins'.[52] Yet, as Davie and Hockney's unique language and contribution to the new and livelier image of British art suggests, for this brief period, their positions on either side of this frontier might be closer than previously thought.

David Hockney: his cigar forms, here, the point of maximum intensity, but it has a rival in the subject of the painting behind him: *The Hypnotist,* 1963, 84 x 84 inches. Right, in gold lamé jacket, with shopping bag to match, on his way back from a shopping expedition in Paddington. Below, *The Marriage of Styles no. 2,* 1963, 72 x 84 inches
(Collection: Contemporary Art Society)

B.R. Born in Bradford in 1937, David Hockney is one of several young artists from the in- dustrialized north of England: for example, Peter Phillips (pages 264-5) and John Hoyland (pages 272-3). The same influx has taken place with pop vocal groups from the Merseyside cellars; and in the English theatre, where a long list of fresh, lively, unconventional young actors have made a special place for themselves on the London scene after early years in provincial repertory companies—the equivalent, in some ways, to a regional art school. However cut off or remote, as students, from metropolitan sophis- tication, these young artists from the provinces bring to London a built-in, edgy, sceptical intelligence and a particular awareness of fashion and 'what's in the air' which give at once an extra drive to their work and a marked irreverence towards prevailing standards and aesthetic issues.

With all its delicacy and subtlety, which can degenerate on occasion into mere frailty and a slightly 'camp' whimsicality, Hockney's work reflects much of his native shrewdness, though its occasional humour is inclined to be overthin and *faux-naïf.* The astuteness, however, com-

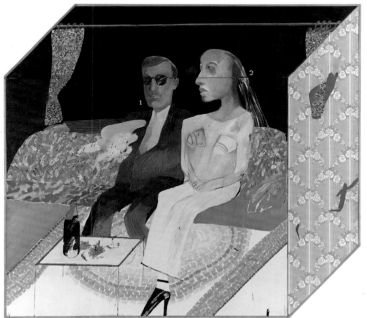

bined with satirical opportunism, does not explain the tough, dry, resilient side to Hockney's pictorial sense, which asserts itself often enough —so far—to save the day. As it is, he walks a tightrope: for the content of his work is rather self-indulgently autobiographical in flavour, and set out in terms which hover between fantasy, into which mawkishness sometimes intrudes, and a poetic realism that can captivate one by its spareness, conciseness, and a totally disarming element of disingenuousness. His sheer artistic intelligence usually wins through. A tendency towards layout and design rather than com- position is offset by his lively games with pictorial and spatial conventions.

The autobiographical factor undermines Hockney's work when minor domestic incidents involving friends, personal souvenirs, and curiously sexless nudes, are all worked into scenes in which the privacy, the 'in' joke, spoils our pleasure (Larry Rivers comes to mind) unless the pictorial conception and the handling of space, shape, line, mass and colour transcends its material. Straight autobiography is rarely sufficient in visual terms; fantasy-autobiography becomes too inbred and tends to stifle or confuse formal development. A further stage in translation is needed, and Hockney does not always push far enough. But his painting continually gets more solid and independent of props. The best of it, and his sharp, knowing attitude towards art and life, have made him a hero figure for his generation.

235

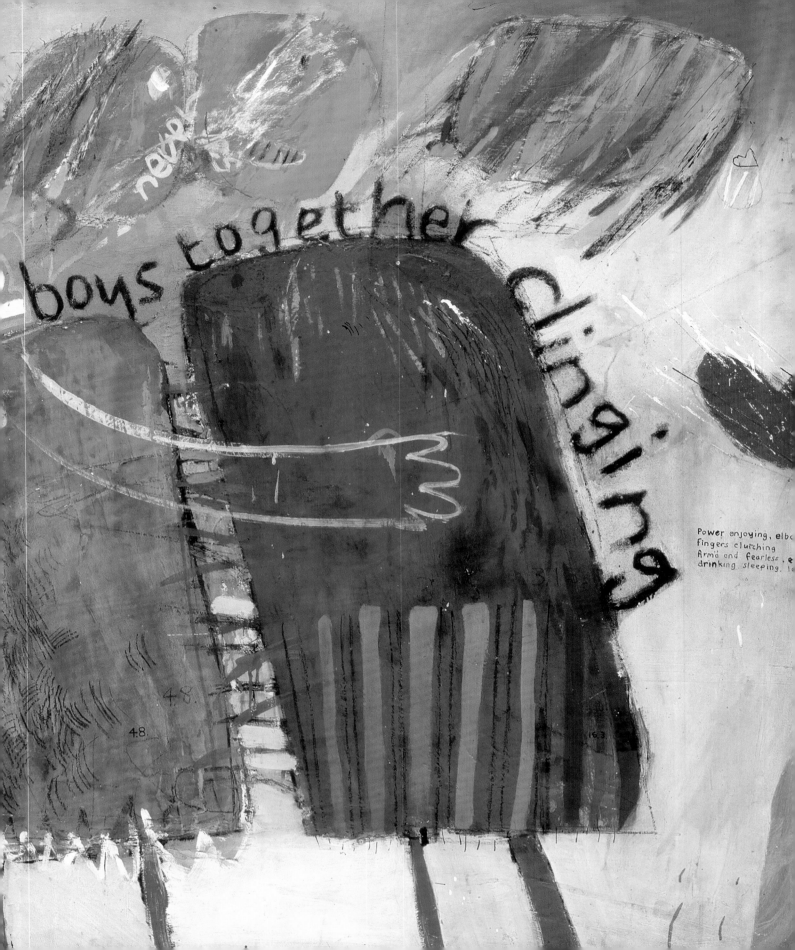

Sing me the Universal: Davie, Hockney, Poetry and Paint

Eleanor Clayton

My voice goes after what my eyes cannot reach,
With the twirl of my tongue I encompass worlds and volumes of worlds.
Walt Whitman, 'Song of Myself'[1]

Under my army bed I discovered a dusty book of poems, and very soon
became a poet, and found The Way at last, and wrote and wrote long
into the night by candlelight.
Alan Davie, 'I Confess'[2]

Both Alan Davie and David Hockney were part of a broader cultural field beyond the boundaries of fine art. Alongside shared but diverging interests in music, both artists were passionately engaged with poetry. Expanding on their shared love of key poets and revisiting the texts and verses that they read reveals something of the ways in which these words inspired their works. Doing so shines a light on the complex relationships that both artists constructed between the creative forces of poetry and paint.

Walt Whitman was an early and strong influence on Davie, who discovered a copy of Whitman's compendium of poetry *Leaves of Grass* under his bunk while in the army in 1943. *Leaves of Grass* was originally published in 1855, although Whitman continued adding to and amending it over the rest of his life. It perhaps found itself in an army barracks due to the number of poems written of Whitman's experiences during the American Civil War, but, for Davie, it introduced the expressive power of language more generally. 'I didn't have any specific feeling I wanted to produce art. In the early years I decided I wanted to be a poet. I felt that poetry had so much more possibilities than painting . . . I was making images through language.'[3]

David Hockney
We Two Boys Together
Clinging (detail) **1961**
Oil paint on board
122 x 152.5 cm (44 x 60 in)
Arts Council Collection,
Southbank Centre, London

Much more than a collection of war poetry, *Leaves of Grass* articulates, in over 400 poems, Whitman's expansive philosophy on the universe and humanity's place within it, particularly celebrating the natural world. Davie's reading of these poems coincided with his first profound encounter with nature while he was in the army, as he recalls, 'I spent half my time wandering in the woods and watching wildlife'.[4]

Davie's own poems frequently celebrated nature with pagan overtones, for example 'Five Duets of the Moon and Frog' 1942–64, which mirrors Whitman's fusion of spirituality and nature.

> Having discovered the
> Bull God asleep by his
> Chariot, the black frog,
> Desiring a night light,
> Created the moon out
> Of an old shoe and hung
> It between his horns.[5]

The inspiration of nature seen in Davie's poetry led to his rebirth as a painter in the late 1940s, as he recalled in 1963: 'We found the mountains and the snows together, and the Italian sunshine, and the marvellous mosaics and the gold and the white and the pink and the bottle-green sea. Then I really began to paint in the way I had learned to write.'[6] Davie's imagery sometimes migrates from page to canvas, for example, *Altar of the Moon* 1955, which could be an illustration of 'Five Duets of the Moon and Frog'. In a lecture in 1966 he expressed his ambition for his painting, 'There is an overpowering need to find unity again with the universal and a search begins for a WAY, in which the making of an IMAGE to contain the forces of NATURE becomes the apparent aim'.[7] This urge to create universal images, now in paint rather than language, echoes Whitman's desire to express the whole of human experience through his art:

> Come said the Muse,
> Sing me a song no poet yet has chanted,
> Sing me the universal.[8]

Of the aspects of Whitman's poetry to chime with both Davie and Hockney, most prominent is the element of sexual expression. Whitman's poetry is joyously, at times explicitly, sexual, and this content led to its censorship by 'the critics of Victorian America who defended the "standard of the evening lamp"'.[9] 'Song of Myself', a central part of *Leaves of Grass*, is a pantheistic anthem, bringing together natural and sexual forces in an overarching celebration of life. This corresponds with Davie's emerging philosophy, as poet Michael Horovitz recalls: 'The mainspring of his practice is the erotic impulse, sort of erotic/romantic. In a way that's a part of his basic universal human appeal, that however abstract it looks, in there somewhere is the whole of human physical experience.'[10] Davie's

Alan Davie
Altar of the Moon **1955**
Oil on Masonite
160 x 241.5 cm (63 x 95 in)
Private Collection, London

monumental painting *Seascape Erotic* 1955 (p.62) shows two touching entities fizzing with attraction, splatters of paint testifying to the passion of their connection. Whitman dedicated several verses of 'Song of Myself' to the erotic power of the ocean, where sexuality and nature collide:

> You Sea! I resign myself to you also – I guess what you mean,
> I behold from the beach your crooked inviting fingers,
> I believe you refuse to go back without feeling of me,
> We must have a turn together, I undress, hurry me out of sight of the land,
> Cushion me soft, rock me in billowy drowse,
> Dash me with amorous wet, I can repay you.[11]

Hockney discovered Whitman through Adrian Berg, a fellow student at the RCA, who was also gay and told Hockney 'of the work of the homosexual poets Walt Whitman and Constantin Cavafy. "I suddenly felt part of a bohemian world", Hockney remembers, "a world about art, poetry and music. I felt a deep part of

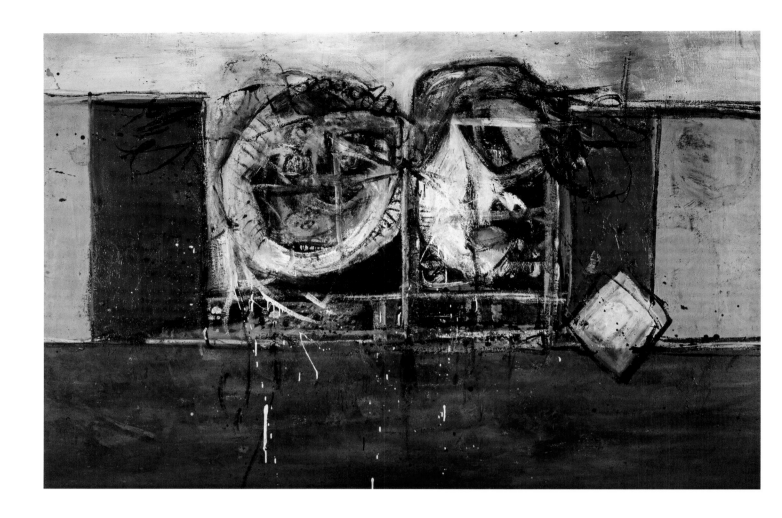

Alan Davie
Seascape Erotic **1955**
Oil on Masonite
160 x 241 cm (63 x 95 in)
National Galleries Scotland.
Purchased 1968.

it rather than any other kind of life. I finally felt I belonged.'''[12] Hockney would go on to make print illustrations of Cavafy's poems in 1966, but the impact of Whitman was so strong it appeared almost immediately in Hockney's first overtly autobiographical work, the etching *Myself and My Heroes* 1961. Three figures appear under the text of the title, each labelled with their first names on their shoulder. Whitman (to the left) has the lines, 'when I thy ports run out' and 'for the dear love of comrades' written on his body, the latter from 'I Hear it was Charged Against Me' and the former possibly an allusion to 'Poem of Joys', both in *Leaves of Grass*. Mahatma Gandhi in the middle has the word 'love' over his head and the text 'vegetarian as well' on his body, and Hockney himself is on the right, declaring through text, 'I am 21 and I wear glasses'. To the right of the image their initials appear in a heart, referencing the 'kind of crude graffiti he [Hockney] had seen in the public toilets of Earl's Court underground station'.[13]

 Leaves of Grass espouses enthusiastic pansexuality, as Whitman writes in 'Spontaneous Me':

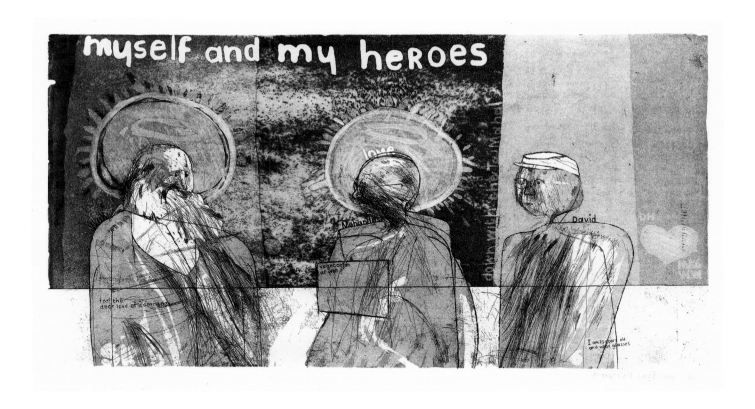

David Hockney
***Myself and My Heroes* 1961**
Etching and aquatint
25.8 x 49.9 cm (10¼ x 19¾ in)
Private Collection

Love-thoughts, love-juice, love-odor, love-yielding, love-climbers,
 and the climbing sap,
Arms and hands of love, lips of love, phallic thumb of love, breasts of love,
 bellies press'd and glued together with love,
Earth of chaste love, life that is only life after love,
The body of my love, the body of the woman I love, the body of the man,
 the body of the earth.[14]

Poems celebrating heterosexual relationships sit alongside those speaking
tenderly and explicitly of homosexual relationships, as in the closing lines of
'When I Heard at the Close of Day':

In the stillness in the autumn moonbeam his face was inclined toward me,
And his arm lay lightly around my breast – and that night was happy.[15]

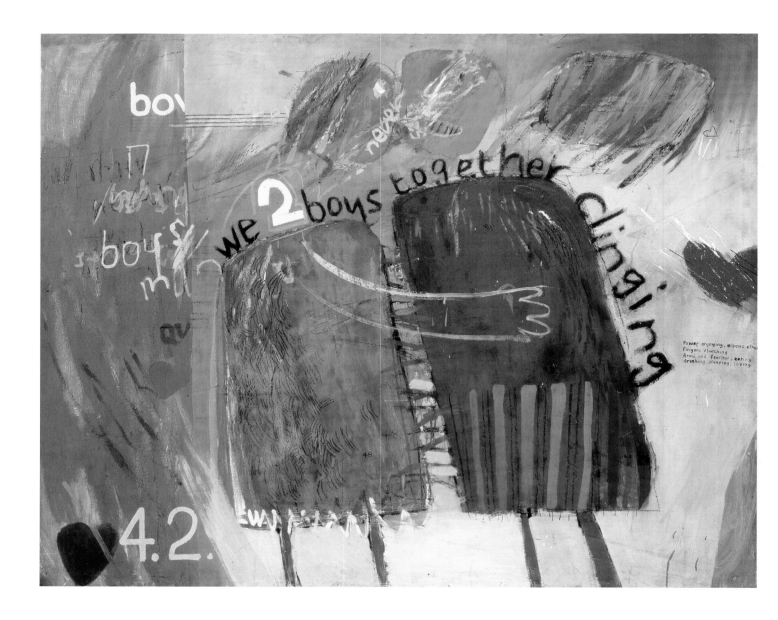

At a time when homosexuality was still illegal in Britain, the celebration of same-sex attraction even within this broader context caused Whitman to become a gay hero.

Hockney made a number of paintings that he described in 1975 as 'partly propaganda of something I felt hadn't been propagandised, especially among students, as a subject: homosexuality'[16] and titled one of the first of these *We Two Boys Together Clinging* 1961, after Whitman's poem of the same name:

> We two boys together clinging,
> One the other never leaving,

David Hockney
We Two Boys Together Clinging **1961**
Oil on board
122 x 152.5 cm (48 x 60 in)
Arts Council Collection,
Southbank Centre, London

Alan Davie
Helen's Hummer **1957**
Oil on paper
42 x 53 cm (16½ x 21 in)
Abbot Hall Art Gallery,
Lakeland Arts Trust, Kendall

Up and down the road going, North and South excursions making,
Power enjoying, elbows stretching, fingers clutching
Arm'd and fearless, eating, drinking, sleeping, loving',[17]

Two figures embrace, their 'bellies press'd and glued together with love',[18] the text of the title wrapping around their shoulders, and the 'never' of 'never leaving' binding their mouths together in a red-lipped, heart-shaped kiss. The heart daubs and scrawled lettering evoke the multilayered texture of a graffitied public wall – Hockney may also have seen Davie using these symbols in works like *Helen's Hummer* 1957. As Hockney wrote, 'When you first look casually at the graffiti on a wall, you don't see all the smaller messages; you see the large ones first and only if

you lean over and look more closely do you get the smaller more neurotic ones'.[19]
Looking closely at this picture reveals the final lines from the poem,
'Power enjoying, elbows stretching, fingers clutching / Arm'd and fearless, eating,
drinking, sleeping, loving', written in small letters to the far right of the image (p.58).

The figures themselves relate to another homosexual literary source,
'Gretchen and the Snurl', a fairytale written by Mark Berger, a fellow student of
Hockney's at the RCA, about a boy named Gretchen who befriends an amorphous
creature with a handsome manly head named 'the Snurl'. The Snurl goes off into
the 'big wide world', advised to avoid the 'snatch' – a colloquialism for a vagina –
depicted by Hockney as a toothy creature labelled 'nasty', and eventually escapes
its clutches to 'live happily ever after' with Gretchen. The final scene of Hockney's
illustrations shows Gretchen and the Snurl embracing in the same composition as
We Two Boys Together Clinging.

Whitman emphasised the fusion of transcendental romance with fleshy
physicality in *Leaves of Grass*, writing in 'Song of Myself', 'I am the poet of the
body and I am the poet of the Soul'.[20] He continues, encouraging the rejection
of shame over sexuality:

Through me forbidden voices,
Voices of sexes and lusts, voices veil'd and I remove the veil,
Voices indecent by me clarified and transfigur'd.[21]

David Hockney
Gretchen and the Snurl 1961
Five etchings with aquatint
28.5 x 79 cm (11¼ x 31 in),
complete work
Mr Timothy Byers

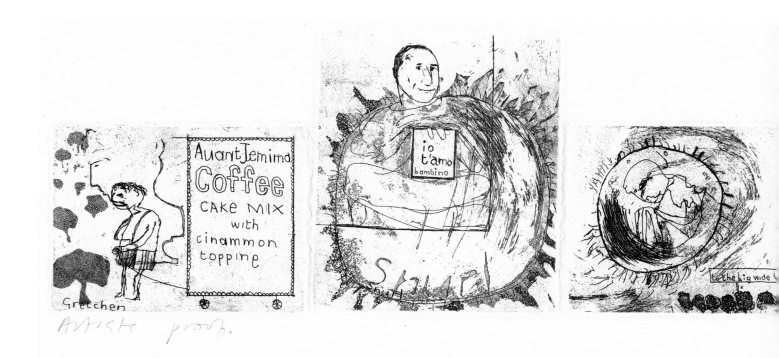

It is little wonder that Hockney was so moved by Whitman's poetry, and a further element of Whitman's mythology entered into Hockney's work of this time. Whitman used a simple, alphabetical code to disguise the names of his male lovers in his private notebooks, in particular '16.4' standing for Peter Doyle, a street-car conductor with whom he had a long relationship and correspondence. Rather than identifying the figures in *We Two Boys Together Clinging* by name, as he had in the less passionate *Myself and My Heroes*, here Hockney labels the figures using Whitman's numerical code. The figure on the right is identified as David Hockney through the repeated appearance of 4.8 (D.H.), while the left figure contains two references, the large 3.18 and the tiny 16.3. The latter refers to Peter Crutch, a fellow student on whom, according to Berger, 'David developed this incredible crush'.[22] 3.18 refers to Cliff Richard, the popular singer who was also a crush of Hockney's. Hockney recalls, 'At the time of the painting I had a newspaper clipping on the wall with the headline "TWO BOYS CLING TO CLIFF ALL NIGHT". There were also a few pictures of Cliff Richard pinned up nearby, although the headline was actually referring to a Bank Holiday mountaineering accident.'[23] The idea of clinging to the handsome singer combined with the poem to create a work that is both moving, romantic, sexual and slightly tongue-in-cheek – as Hockney recalled, 'because it was a part of me it was a subject that I could treat humorously'.[24] The largest numbers in the painting, 4.2, refer to 'Doll Boy', another name for Richard based on his 1959 hit, 'Living Doll'.

Later that year Hockney would make another painting referencing Whitman, again of two figures seemingly romantically linked, *For the Dear Love of Comrades*

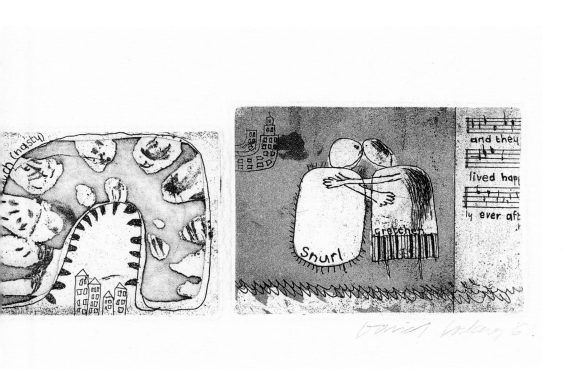

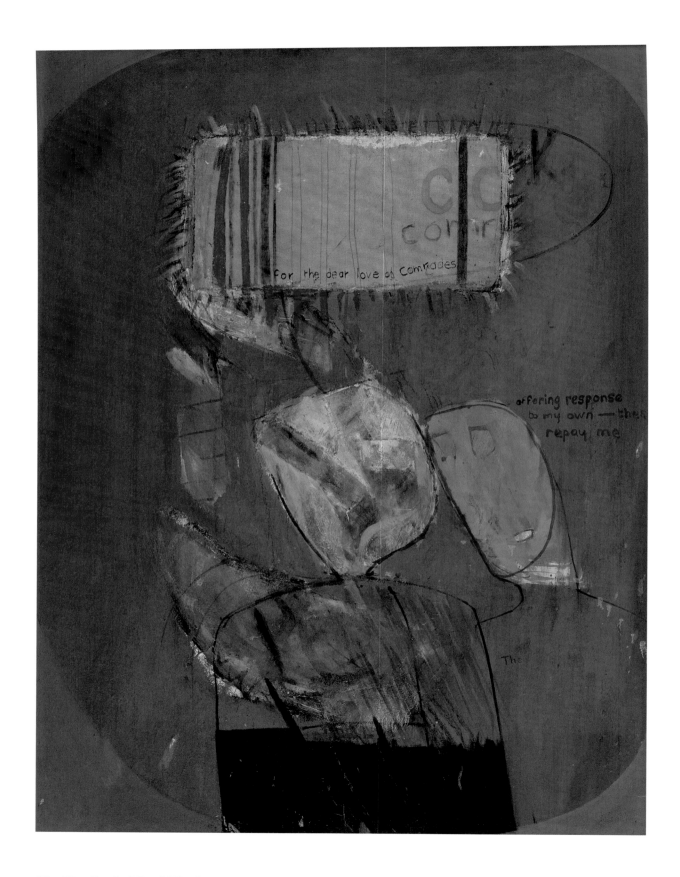

Opposite
David Hockney
For the Dear Love of Comrades
1961–2
Mixed media on board
120.7 x 90.2 cm (47½ x 35½ in)
Royal College of Art

1961–2. Their heads lean against each other while a patch of bare canvas appears to be carried aloft, inscribed with the titular words, 'for the dear love of comrades', the last line from Whitman's 'I Hear it Was Charged Against Me':

> I hear it was charged against me that I sought to destroy institutions,
> But really I am neither for nor against institutions,
> (What indeed have I in common with them? Or what with the destruction
> of them?)
> Only I will establish in the Mannahatta and in every city of these States
> inland and seaboard,
> And in the fields and woods, and above every keel little or large that
> dents the water,
> Without edifices or rules or trustees or any argument,
> The institution of the dear love of comrades.[25]

This has been seen by some as Whitman's defence of his homosexual poetry;[26] that he does not intend to make a case for or against either societal 'institution' but simply to espouse free and unfettered love for all humankind, a sentiment that resonated with Hockney's generation at the cusp of the 1960s 'free love' movement. Hockney references another section of poem within the painting with smaller writing, 'offering response to my own – these repay me'. It comes from a passage of Whitman's poem titled 'City of Orgies' that celebrates plentiful sexual encounters:

> City of orgies, walks and joys,
> . . . as I pass O Manhattan, your frequent and swift flash of eyes
> offering me love,
> Offering response to my own – these repay me,
> Lovers, continual lovers, only repay me.[27]

This suggests the sense of freedom Hockney felt having left small-town Bradford and moved into what was fast becoming the centre of 'swinging London', a sense that was to expand dramatically with his trips to Los Angeles. Although Davie may seem the antithesis of swinging London – a teetotaller who had a lifelong, monogamous relationship with his wife Bili – he was also fiercely anti-establishment. Prominently, he railed against formal art education, the academic style of draughtsmanship in which both he and Hockney had been trained, and developed radical, progressive approaches to teaching.[28] He explained his problem with these institutions, noting 'they seem to think, you've got to study, you've got to practise before you can become an artist, which seems to me absolute nonsense. Being an artist is "now", it's not later.'[29] This sentiment is reflected by Whitman:

> I have heard what the talkers were talking, the talk of the beginning and the end,
> But I do not talk of the beginning or the end.
> There was never any more inception than there is now.[30]

Both artists were inspired by other poets besides Whitman. Davie recalled,

having discovered this Walt Whitman book of poetry . . . I used to go
into the bookshops and into the literature and poetry department and
I discovered all sorts of fantastic things; James Joyce – which was a
revelation – that was some direction which seemed to me natural, Ezra
Pound, Herbert Read, all the modern poets who I had never heard of before,
who were all completely new to me.[31]

William Blake was another 19th-century inspiration alongside Whitman, similarly
fusing transcendental philosophy with a celebration of the physical world. Davie
reportedly commented, 'My work belongs to nature, if people would only look
closely at nature itself revealing its marvels. Like Blake, "to see the world in a grain

Above left
Alan Davie
***Untitled [nude study]* 1939**
Pencil on paper
38.5 x 28.3 cm (15 x 11 in)
Private Collection, Devon

Above
Alan Davie
***Untitled [nude study]* 1939**
Pencil on paper
38.5 x 28.3 cm (15 x 11 in)
Private Collection, Devon

David Hockney
***The Fires of Furious Desire* 1961**
Etching and aquatint
14.5 x 28 cm (5¾ x 11 in)
Mr Timothy Byers

of sand".[32] He refers to Blake's 'Auguries of Innocence', first published in 1863, whose first lines read:

> To see a World in a Grain of Sand
> And a Heaven in a Wild Flower
> Hold Infinity in the palm of your hand
> And Eternity in an hour[33]

That Davie references Blake is perhaps unsurprising given the latter's prominence in the emerging counterculture of the late 1950s and early 1960s, promoted most energetically by beat poet Allen Ginsberg. Davie encountered the beat poets partly through their mutual close association with the jazz scene, but also through his involvement with the literary periodical *New Departures*. The editor of *New Departures*, the poet Michael Horovitz, invited Davie to contribute after hearing him talk in Oxford in 1959.[34] His essay, 'Towards a New Definition of Art', featured in the second issue in 1960 alongside beat poets Gregory Corso, Allen Ginsberg and Jack Kerouac. Ginsberg's promotion of Blake within this context had begun in 1948 with what he referred to as his 'Blake Vision',[35] an auditory hallucination he experienced while reading Blake's poetry, which was to affect his whole view of the universe. He would go on to release a recording of Blake's *Songs of Innocence and Experience*, originally published in 1789, 'tuned

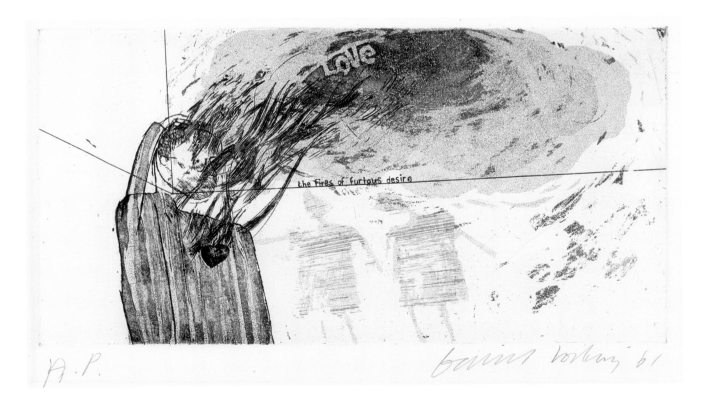

by Allen Ginsberg' in 1969, and read his political works such as 'The Grey Monk' at protests against the Vietnam war.[36] Blake became synonymous with both beat poetry and 1960s counterculture; for example, Aldous Huxley took the title of his psychedelic account of mescaline experiments, *The Doors of Perception* (1954), from a line in Blake's poem 'The Marriage of Heaven and Hell' (1790):

> . . . the notion that man has a body distinct from his soul, is to be expunged;
> this I shall do, by printing in the infernal method, by corrosives, which in
> Hell are salutary and medicinal, melting apparent surfaces away,
> and displaying the infinite which was hid.
> If the doors of perception were cleansed everything would appear
> to man as it is, infinite.[37]

Key themes emerge across Davie's poetic inspirations from Whitman to Blake – the idea of the infinite in the present and the connection of the physical and transcendental.

Hockney also included references to Blake within his work. Several abstract paintings in 1960 titled a variation of *Tyger* (*Tyger Painting no.2*, *Big Tyger* etc.) took inspiration from the poem 'The Tyger',[38] also in Blake's *Songs of Innocence and Experience*, and include the word 'Tyger' scrawled across the canvases in paint. A more complex sampling of Blake's poetry is found in the etching *The Fires of Furious Desire* 1961 (p.71), which shows a figure with a prominent heart projecting flames and smoke – labelled as 'LOVE' – into the atmosphere over two unidentified, anonymous figures. The title, written again in small text across the centre of the image, paraphrases a line from Blake's 'Jerusalem' of 1804:

> Reader! Lover of books! Lover of heaven,
> And of the God from whom all books are given,
> Who in mysterious Sinai's awful cave,
> To Man the wondrous art of writing gave,
> Again He speaks in thunder and in fire!
> Thunder of Thought and flames of fierce Desire;
> Even from the depths of Hell His voice I hear
> Within the unfathom'd caverns of my Ear.
> Therefore I print; nor vain my types shall be.
> Heaven, Earth & Hell, henceforth shall live in harmony.[39]

Blake speaks of using the God-given gift of writing – and print production – to present the gamut of human experience, bridging the gap between physical and transcendental, good and bad, to bring 'Heaven, Earth & Hell' into harmony. Hockney takes this overarching sense of freedom, celebration of the creative self and lack of judgement, and makes it personal. He describes the etching as 'a little self-portrait', presenting himself as someone bursting with love.[40]

Opposite
David Hockney
The Actor 1964
Acrylic on canvas
166.5 x 167.3 cm (65½ x 66 in)
National Museum of Wales

Although both drawn to similar poetic sources, Davie and Hockney enfolded these texts into their creative processes in different ways. For Hockney, the poetry of others was both inspiration and source material. In the same way that he sampled visual styles from Egyptian art to Picasso's cubism, he also sampled poetry, fragmenting and repositioning lines alongside popular, colloquial texts to create his own message. His use of words was a communicative tactic that he initially considered as a way of substituting figurative elements – although text and figures often appear alongside one another – reflecting, 'When you put a word on a painting, it has a similar effect in a way to a figure; it's a little bit of a human thing'.[41] This interplay between different communicative elements; symbols, figures, images, text, has led Hockney's early work to be described by Andrew Brighton as akin to 'playfully self-conscious modernist poetry'.[42]

In the 1960s Davie shifted towards a similar aesthetic, increasingly creating flat planes populated by text alongside a panoply of visual symbols. He recalls, 'I became very fascinated with symbolism and symbols . . . one found the same symbols from the beginning of man's art, and throughout all cultures, all kinds of civilisations . . . there's some magic in the symbolism which goes straight through all culture, and which we all recognise'.[43] As an early review by fellow painter Patrick Heron noted, for Davie these symbols communicate something 'undecipherable', describing him as 'an intuitive romantic' for whom these marks become 'symbols of symbols', suggesting a poetic form without overtly or simply communicated content.[44] Although at times particular imagery and ideas migrated between page and canvas, Davie's painting and poetry are more often simultaneous expressions, to be viewed alongside his musical and other creative activities as one holistic artistic project. As poet Michael Horovitz deftly articulates, for Davie, painting itself is 'sheer poetry of a kind'.[45]

Opposite
Alan Davie
Good Morning My Sweet no.2
1968
Oil on canvas
122 x 151 cm (48 x 59½ in)
Sylvia Thompson

towards art?

The contribution of the RCA to the Fine Arts 1952-62

Conversations: From Post-War Austerity to the Swinging Sixties

Edited and introduced by Dr Rachel Stratton

This collection of conversations offers a rare opportunity to hear from the curators, critics, art historians, collectors and peers who knew and supported Alan Davie and David Hockney during the period covered by this volume. These contemporary voices breathe life into the nexus of the art industry in Britain and create an evocative picture of the atmosphere in London as it shifted from post-war austerity to the Swinging Sixties. Out of the reminiscences, Davie and Hockney emerge as wildly different personalities who nevertheless shared many of the same passions, artistic concerns and friends. Similar themes ripple through the interviews, establishing moments of interconnectedness between the interviewees and forming a collage of the place Davie and Hockney occupied in this dynamic period of British art.

The interviewees represent different facets of these artists' early careers. The perspectives of art historians and critics sit at one end of the spectrum, their critical distance providing insight into the structures (museums, galleries and media) that gave them visibility. Alan Bowness, one of the foremost art historians and curators of modern art in Britain, and subsequently Director of Tate (1980–88), played a significant role in the establishment of both artists,

writing on Davie and including him and Hockney in exhibitions at Tate in the 1960s. His statement evokes the intimacy of the contemporary art scene in the 1950s and Davie's central position in it. The critic Marina Vaizey offers a perspective from the other end of the period, providing fascinating insight into the changing atmosphere of the contemporary art world in the 1960s and the part Hockney played in making art newsworthy.

Equally important as those who write about the artists are those who collect their work. Ronnie Duncan is a prolific collector of post-war British art, beginning in 1948 from his home in Yorkshire, and he became a major collector of Davie's work in the 1950s. His eloquent reminiscences of encountering Davie's work in Leeds convey a sense of the awe that Davie's remarkable process inspired. Sylvia Thompson, another friend and collector of Davie's, conjures a picture of the social scene among the artists that congregated in St Ives and the surrounding area. Lindy Hamilton-Temple-Blackwood, Marchioness of Dufferin and Ava, a prodigious patron of the arts and hostess to the Swinging Sixties' crowd, offers insight into the establishment of the Kasmin Gallery that represented Hockney and for which her husband, Sheridan, was the principal backer.

David Hockney, Poster for *Towards Art: The Contribution of the RCA to the fine arts 1952-62* exhibition held at Royal College of Art 7 November – 1 December 1962. Royal College of Art Archive

The visual arts were part of a wider cultural milieu and this is noted by the inclusion of poet and artist Michael Horovitz, who knew both Davie and Hockney in the late 1950s and 1960s. Horovitz's journal *New Departures* was one of the first to introduce the American beat poets to Britain and also included essays and drawings by Davie and Hockney, with whom he shared many of the same interests. Horovitz's account of the events and characters of the early 1960s accompanies the reminiscences of Hockney's art school peers, John Loker and Derek Boshier. Loker trained with Hockney at Bradford School of Art (1954–8) and at the Royal College of Art (1960–63), one of four artists who became known as the 'Bradford Mafia'. Boshier was also a contemporary of Hockney's at the RCA (1959–62), becoming a leading figure in British Pop art. Their memories capture the vibrant atmosphere and proliferation of visual material they consumed in this early stage of their careers.

The recurring themes in these recollections reveal the two artists' proximity. Their love of poetry and use of language in their art, and in particular their shared adoration of Walt Whitman, features prominently. Music also takes a central position, for Davie, the freedom and improvisation of jazz and, for Hockney, the tight compositions of the classical genre. Throughout, these artists are presented as polymaths, their talents extending to multiple arenas in the cultural field and their voracious appetites for knowledge apparent in the literature, music and art they consumed. The vital importance of print culture and mass media also becomes apparent, especially with the birth of the *Sunday Times* colour supplements in 1962, which publicised contemporary art to mass audiences for the first time. The emergence of new commercial galleries supporting contemporary artists is discussed, and the vital role of the Whitechapel Gallery, run by Bryan Robertson, is cited as a beacon for contemporary art in an otherwise conservative museum establishment. These statements made by friends and supporters paint a vivid picture of the shifting cultural environment of the late 1950s and early 1960s, contextualising the artistic dialogue between Davie and Hockney.

Alan Bowness[1]

I was involved in the modern art scene at a very early age. When I was still a schoolboy I started going to exhibitions in London at the small dealers' galleries that showed modern art, like the Lefevre, Redfern and Leicester galleries. Graham Sutherland and [Henry] Moore were the leading figures in British art at that time, 1944–6. I was more interested in the new generation, John Minton, Keith Vaughan, Lucian Freud, John Craxton, Michael Ayrton, and the two Roberts, Colquhoun and McBryde. Ayrton was only ten years older than me, so there was a feeling that they were almost my generation.

I arrived in Cambridge in 1950 as an undergraduate at Downing to read French and German, and then I went to the Courtauld as a postgraduate student – I was there from the summer of 1953 to 1955. I used to go around all the galleries in London. I saw everything. That was the time when there were new galleries opening, such as Roland, Browse & Delbanco, Beaux Arts, the Hanover Gallery and Gimpel Fils. And I was obviously interested in the new artists who were beginning to appear, such as Alan Davie.

I was aware of Davie, as part of a group of avant-garde artists including [William] Scott, [Roger] Hilton, [Peter] Lanyon and [Patrick] Heron, who were all quite prominent in that very small field of modern art – the audience was tiny then. In a way it was very nice because it was more intimate, so you got to know people much more quickly. I met Alan at the time. He was quite formidable, a bit frightening! It may be that it was a kind of shyness: I would say that he wasn't very good in his relationships with people. Alan played a part in creating an image of himself through photographic portraits. He probably thought it was important that he was immediately identified as an artist.

Alan moved out to the countryside, to Hertfordshire, at quite an early date, away from the London art scene. He was already spending his summers in Cornwall, but chose to live in this little cottage near Lands End, at least 45 minutes' drive away from St Ives. He knew Lanyon well, and [Terry] Frost. Alan would sometimes turn up at a party or an opening in St Ives, but we never saw very much of him. He kept himself to himself. I thought about this in relation to his jazz. He was an excellent jazz musician, and would play something on the flute and record himself playing it on tape, and then he would pick up a guitar, play the tape back and play a guitar part over the top, and so on and so on, building a piece of music, all by himself. After he moved out of London, from 1958 onwards, I used to sometimes go out and see him, and of course I always saw his exhibitions.

The first Gimpels' show was 1950, and then 1952, 1954, 1956. That was the pattern, a one-man-show every two years, for Lanyon and various other artists who were taken up by the Gimpels. Charles and Peter Gimpel were a very sophisticated couple, two Anglo-French brothers with very strong family links in the art dealing business. They were very smart indeed in those early days, picking up many of the most interesting talents of the early 1950s. Alan's work was interesting for its sheer originality. It also had this kind of visionary quality. It was very hard to understand. I enjoyed trying to write about it.

I was an art critic from around 1953–4 when I was at the Courtauld, writing in *Art News & Review*, a fortnightly newspaper which reviewed all exhibitions. [David] Sylvester and [Lawrence] Alloway, Reyner Banham and myself, we all used to write for it. Then in 1955, when I was just leaving the Courtauld, Anthony Blunt asked me if I would like to review Patrick Heron's book *The Changing Forms of Art* for *The Observer*. He had been asked by *The Observer*'s literary editor, Terry Kilmartin. Terry had asked Anthony to recommend a younger critic to review Patrick Heron's book. So I had made a bow, as it were, in 1955, writing in *The Observer* as its second art critic. And at that precise point I was

under the influence of John Berger, who was a very powerful figure at that time, when it seemed that the future of art rested with some kind of new social realism.

What we soon realised, however, was that while Europe had been asleep in the 1940s because of the war, all sorts of fascinating things had been going on in New York. The moment the penny dropped was between two crucial exhibitions of American art in 1956 and 1959 at the Tate. We all realised suddenly that abstract art, which had been dismissed as being a dead end, was actually not one style but a whole multiplicity of styles, as we saw from the Americans; from a very free kind of painting, as in Pollock, or pure colour, as in Rothko, to a very measured kind of discipline, as in constructive art, and all sorts of things in between. Things moved very quickly in the 1950s. That was what was so interesting.

I was still writing art criticism until the early 1960s when I got the chance to make exhibitions, particularly the big Gulbenkian exhibition *54–64* at the Tate [in 1964] that I did with Lawrence Gowing. We had both thought that it would be a good idea to celebrate 50 years since Roger Fry's great Post-Impressionist exhibitions. This should have been in 1960 or 1962 but things moved rather slowly. Lawrence managed to persuade the Gulbenkian Foundation, which was a new charity on the scene, to sponsor a big exhibition that would, not exactly replicate Fry, but would have the same kind of impact.

The great idea was to bring British artists into an international context, just as Fry had shown British artists, particularly in the second Post-Impressionist exhibition. He had shown them in the context of French – or rather Parisian – painting, German painting and Russian painting. We thought this was the moment when we would show the British painters and sculptors in the context of European art on the one hand, and American art on the other.

As with the later Stuyvesant show of British painting in 1967, I was the person with most time to spend on the exhibition, because Gowing was

54

Painting & Sculpture of a Decade

64

running an art school. The head of the Arts Council's art department, Philip James, was brought in as a third member of the triumvirate. I instigated the pattern of the exhibition, which was to have three categories of artists: a category of major artists who showed five or six works and had a colour reproduction in the catalogue; a larger, middle generation of artists who had three works and a black and white illustration; then the token appearance of much younger artists which we tried to keep open to the last minute. The selection of the younger artists was basically my choice. Davie comes in this big middle section of the catalogue with four paintings, one in colour, *Seascape Erotic* [1955]. That tells you how significant he was, the same number of works as Jasper Johns, for example. There were four of [Ron] Kitaj's, which shows you how we admired him. Two Hockneys; he and Allen Jones were the youngest artists in the show.

Turning to Hockney, I had joined the art panel of the Arts Council in 1960, and two members of the panel each year were invited to buy contemporary British paintings and sculpture for the Arts Council Collection. Lawrence and I worked together to buy paintings. We got a message from the Arts Council asking us to go to the annual exhibition of the London Group and see if there was anything outstanding. The London Group was an artists' cooperative which had been going since 1914. So Lawrence and I duly went along. We were walking round and round trying to find something we thought worth buying. I found it pretty dispiriting. Eventually, I persuaded Lawrence to buy a picture by an artist neither of us had ever heard of, David Hockney. We had no idea who he was. We made this recommendation that the Arts Council should buy this picture (*November*) – it wasn't very expensive – and the Arts Council went ahead and bought it. Somebody said, 'You do realise that he's a student at the Royal College?' Lawrence was horrified. I was quite amused, actually. I liked the picture, partly because it was in the style of Davie. I'm sure he must have seen Davie's exhibitions at the Gimpels' or in Wakefield, it would be rather surprising to me if he hadn't.

I met Hockney because I was interested in what the art students were doing. I was more closely associated with the Slade School in those days, with the two Cohen brothers, Harold and Bernard, doing something exciting and rather different, but I had been aware of each generation at the Royal College: the kitchen-sink painters Jack Smith and John Bratby, Joe Tilson and Bridget Riley, and then the first painters who were influenced by the impact of American art, Richard Smith and Robyn Denny. Then, of course, David arrived at the Royal College in 1959. I probably saw his work in the print room first. The painting students had to do some work in the graphic department, which was a bit of a poor relation but David loved it: I remember well his making *Myself and My Heroes*.

What changed David was Ron Kitaj's impact. Kitaj had been studying in Oxford, at the Ruskin on a GI grant, but he thought they were fuddy-duddies and not very interesting, so he moved to the Royal College in 1959 as a postgraduate student. He was a year or two older than Hockney and the others.

All of us in that generation had to spend two, or three, or four years doing National Service, or its equivalent, so we were all rather more mature than earlier and later students. There were a number of others too: Allen Jones, Peter Phillips, Patrick Caulfield. Then in the background was Peter Blake, who had some kind of postgraduate scholarship. I always went to the graduation shows at the Royal College, Slade and Chelsea. They were the three schools which had interesting students.

It was obvious even then that Hockney was fantastic. I also thought that Kitaj and Allen Jones were outstanding. The Royal College authorities were a bit worried because they thought these were revolutionary students who were creating turbulence, and felt they had better make an example. They couldn't sack Kitaj, because he was an American on a big grant, and they couldn't sack David, because he was a country boy, but Allen Jones, who was a rather smart Londoner, got kicked out of the College after the first year. They made an example of him. But they very quickly realised, by the time the third year came round, that they had another wonderful group and gave David the gold medal.

Kitaj told Hockney, 'You've got to paint from your experience. You've not got to work in somebody else's abstract medium. Even creating your own abstract medium is not quite the same.' Kitaj was also pointing ahead in his own way. Ron was not homosexual, but he encouraged David to speak out on his homosexuality. It was very bold at that time, to paint that specific subject.

A year or two later when Hockney was beginning to get established, he asked the Arts Council if they would exchange *November* for a more recent painting. The Arts Council agreed and we chose instead *We Two Boys Together Clinging* [1961].

Ronnie Duncan[2]

When Alan Davie arrived in Leeds in 1957 to take up the Gregory Fellowship of Painting at the university, succeeding Terry Frost, I was in for a shock. At the start of my collecting career, I'd only just come to terms with Frost's comparatively structured abstractions: both to enjoy and to buy. With Davie's painting I was initially hostile (often a healthy reaction when confronted by innovative work). I found it messy, inchoate, meaningless, although I was sufficiently intrigued to invite myself to visit him in the studios reserved for the university's successive Fellows of Painting and Sculpture.

Here was this tall, bearded Scot who seemed to know exactly what he was about: working simultaneously on a dozen huge canvases and perhaps throwing off a score of drawings in a single session. I couldn't relate to all this activity, but I kept on visiting him. I'd steer the conversation away from art onto topics and activities I knew engaged him: music (especially jazz), Zen Buddhism, snorkelling, gliding, sailing. However, throughout these sessions Alan's paintings were beaming down from the walls, thrusting for attention, so it happened that rather than my coming to them, they came to me. The time arrived when, in [Rainer Maria] Rilke's words on Cézanne, I had the 'right eyes'. My reward was to be released not just into acceptance of the work, but into the limitless possibilities of the medium itself: paint. It was an unsettling experience because it subverted my assumptions about the human agency, the role of the artist himself in the creation of works of art.

If I'm to convey a meaningful sense of this revelation I need to describe Alan's process, his way of working. On one occasion when I visited the studio, he had torn sheets of the coarsest wrapping paper into rough strips and laid down 20 or so on the studio floor. Arranged around the wall stood buckets of paint mostly containing primary colours, each with its own decorator's brush. Taking up a brush of, say, yellow, Alan advanced on each of the sheets in turn, painting a simple geometric shape. Taking up another brush of say, blue, he added

a different shape alongside the first, repeating the process with further unmixed colours until the sheets' surfaces were all but covered. By this time the sheets still bore a family resemblance to each other, but the overflowing brush and almost slapdash application of paint had conferred a measure of individuality upon each one.

It was now that the magic began. Abandoning the big brushes and the buckets of colour, Davie took up small brushes, black and white. Stooping over the sheets in turn he moved rapidly, sinuously: joining, dividing, overlaying, stabbing, flicking. His whole body was engaged with process, his demeanour one of relaxed intentness; brush, hand and arm seemingly an extension from shoulder. The immediate impact on me of watching this seemingly anarchic process was delight and wonderment of what paint could do when – as it were – let loose. But this reaction fell short of arriving at the 'understanding' I sought.

The show in Wakefield was the beginning of Davie's reputation in this country, without any doubt. I was very friendly with Helen Kapp at that time. She would give a room in Wakefield Art Gallery in one of her annual shows to the Gregory Fellow of the day. When she first saw Davie's work she couldn't deal with it, she couldn't offer it to him. Helen was a very skilled curator, but she still had the same hostile reaction to Alan's work as I did at the time. But her conversion was as complete as mine, and she ended up giving him the whole of the gallery. That was the nucleus of the show that went on to the Whitechapel, and that show really got him going in this country.

The public reacted to the Wakefield show with bewilderment, people's expectations were confounded. The works had this tremendous attack. What is so difficult to describe now, when we're so familiar with all kinds of painting and wouldn't be thrown by Jackson Pollock, is that in the mid-1950s we were struggling to come to terms with structured abstraction, never mind someone who threw the whole thing over and painted like that. Alan was amazing, sometimes when I visited him in

'Alan Davie with his Poodle',
from *Private View: the Lively
World of British Art* , 1965,
edited by Bryan Robertson
and John Russell, photograph
by Lord Snowdon

the studio he would say, 'Come on in, take a brush', and I might take a tentative few dabs. It was kind of controlled chaos, a paradox. The excitement, and to me, the great glory of Davie was during the 15 years between the mid-1950s to the late 1960s. I saw the change happening (towards the spare, almost cheeky, works of the 1960s like *Mango Time*) but they didn't have the energy and spontaneity of the earlier work. The explosion of colours is the essence of the Davie I loved, one that blew one away in terms of colour, movement and energy.

He was thought of as being rather dour, never 'one of the boys'. I never heard him talk about other artists; he was completely self-sufficient, self-absorbed creatively. He obviously wasn't unaware of what was going on and must have been aware of Hockney's generation, but he was so dedicated to what he was doing, he never really talked about them.

This detachment should be seen in the context of how his work was received at that time: ferocious attacks or blank incomprehension; hardly anyone buying, Gimpel Fils, his lifelong gallery, supported him for eight years without a sale. I remember Alan's wearied response to criticism, 'My work belongs to nature, if people would only look closely at nature itself revealing its marvels. Like Blake, "to see a world in a grain of sand".' The impression he gave of complete assurance in his work masked bouts of doubts and despair, but I only learnt this years later when he was famous and successful. In 1966, responding to my comments on one of his exhibitions, he wrote, 'How nice it is to get a "live" reaction to my work – any reaction for all that matter . . . So many times I feel like giving up the whole awful business of painting. Particularly with all the contact we have thrust upon us by those quite depressing visits of Americans buying, desperately seeking CULTURE. But then the mystical process takes over, and the struggles to try to understand and control become more and more impossible. How can one possibly judge, when judgement itself is always changing. Yet the attempt is part of the process.' Alan Davie will remain the most exciting artist I've known in a long collecting career.

Sylvia Thompson[3]

I met Ronnie [Duncan] in the 1950s, at a party of a friend of mine who was at the art college [in Leeds] and was a great potter. A lot of the artists and students used to congregate at her studio in Chapeltown. Through Ronnie I met the Gregory Fellows. I remember meeting Alan in Cottage Road, where the Gregory Fellows' house was. I was nervous because I wasn't from an art background. When I went to the studio there was Alan on the floor doing all this dramatically active painting.

I was just fascinated. I thought it was terrific, this lovely movement of his arm and this great long beard and low, soft, Scottish voice. It was all very new to me, and fascinating. And then these wonderful paintings on the wall with flashes of colour. It was exciting to meet someone who was working like that, with so much energy. He was very musical too, he played jazz and classical music, many different instruments.

Ronnie and I used to go to Cornwall because we had got to know the Gregory Fellows: Trevor Bell, Terry Frost and of course Alan. We used to go to 'The Bottoms', where Alan lived. There was colour and flowers everywhere. Bili [Davie] was great at making colourful displays of flowers because she was an artist in her own right and I think she gave up a lot of her own creativity because she was so devoted to promoting Alan. She also made the carpets that he designed.

The painting studio at 'The Bottoms' was a building in the garden, the loft of the old stable. I remember going and seeing all these incredible, lively works on the wall everywhere, everything was alive with colour. But Alan wasn't pushy, he was very shy, he wasn't very talkative. Alan didn't mix with the other artists in St Ives, he was very much his own man, but he was friendly with Patrick Heron and also Peter Lanyon.

Alan wrote incredible things. He was influenced by Walt Whitman whom he discovered during his army days and had been writing since then. His father kept all the letters he wrote to him

Alan Davie's studio is a huge white room, as big as a municipal swimming bath, which he built on to his house in Hertfordshire. It can accomodate even the largest canvas with ease

Alan Davie in _Private View: the Lively World of British Art_, 1965, edited by Bryan Robertson and John Russell, photograph by Lord Snowdon

never stopped! Alan was a genius, he was all as one creatively – all the different sides of him, the music and the writing, all came through in his painting.

Michael Horovitz[4]

I first met Alan Davie when he came to give a talk in Oxford. I think I was in my last or penultimate year as an Oxford undergraduate. I was sharing a cottage outside the city with Bill [William] Tucker – who since became a quite celebrated sculptor – and a fellow poet called Chris Salvesen. We had befriended two American ex-GIs over on American arts scholarships, Bill Spooner and Ron Kitaj. Kitaj was mainly at the Ruskin School of Art, where he was immediately embroiled in all sorts of Oxford art activities. He was a great example to us. We had read about and imagined Van Gogh and people going off for the day with their art materials in a rucksack and both Kitaj and Spooner were doing that. I retained a close friendship with Kitaj, who later became one of Hockney's very best friends.

Alan's talk was at my college, Brasenose. We loved it. Alan welcomed people to interrupt and ask things and always gave excellent responses. His way of talking was so different from much of the communications that were circulating around Oxford in the late 1950s. There was a sense that: 'Modern art, it's so pretentious. Who needs all this Johnny Foreigners' Picasso, and suchlike.' It was to some extent the knee-jerk Alfred Munnings tradition.

After the main talk, as usually happens, a few of us hung around and repaired to a pub, probably The Mitre. Though Alan wasn't a drinking man, he seemed to like our company and chatting with us and we quite revered him, having seen reproductions of his work and maybe one or two originals here or there that passed through Oxford. This second session lasted into the small hours and we became more and more mutually beguiled by each other. Eventually, we could see Alan was getting tired and needed to rest, so we left him but got to know how to reach him.

and had them bound in these wonderful books. Alan had an interesting library, including books on many artists and on African art.

He also had a great sense of humour, which sometimes came through in his painting. What I picked up on was the movement of the words within his paintings, if you look at them – the flowing brushstrokes. It's not just what the words said, it's the movement of the letters. When he was painting, he moved like he was conducting an orchestra. He never stopped drawing, his words to me were that 'it was like a disease' – from morning to night he

After graduating from Oxford in 1959, I started *New Departures* and I sent Alan the first issue and asked if he'd like to contribute to the second one. He sent me this lovely account, 'Towards a New Definition of Art', which covered a lot of the ground we were also trying to explore, in the sense that it didn't see the point of just continuing what had been done so well over the centuries by previous modern artists of their time. In this essay-cum-memoir, Alan asks questions like: 'Is there an inner and (outer) space?' and 'Is the universe in me too?' He makes the point that Schoenberg and the 12-tone system of music were not radically unprecedented matters but that most music and all art is timeless, so that you can befriend William Blake or Arnold Schoenberg or the people who made the Parthenon or painted on cave walls, knowing they are your spiritual contemporaries. Bill Tucker, Salvesen, myself and Anna Lovell, having started *New Departures*, were more and more galvanised and inspired by Alan Davie.

I remember some of his students describing his techniques to get people to open up and enjoy themselves and realise that painting and drawing were great fun. They were astonished that this man said things like, 'Just regard what you're doing as shedding your inhibitions. You know what you've done before. What you want to do is something else, so I suggest if you can't find inspiration, just paint the most horrible, disgusting, filthy imagery and words, filthy words. Paint them, paint them and you can paint over them. You don't need to worry. It's just marks. Marks on your papers, on your canvas. Rejoice! You're having a good time!'

I became more and more excited by every exhibition where Alan's works were exhibited and I remember in particular a massive one, probably early to mid-1960s in what was then called the RBA gallery. It showed just how wildly adventurous a painter he was. When it had all been hung, the day before the private view, he was charging around with pots of turpentine and things, putting finishing touches and offering the paint pot, saying, 'Cocktail? Cocktail? Free, free, private view!' We inhaled the pleasurable stench and ebullient flow of his creativity.

As for David Hockney, he was living, all the time I knew him best, at the end of the next block. We didn't actually speak until the *Young Contemporaries* exhibition at the RBA gallery [1962]. I had been asked by the organisers to bring a troupe of poets and musicians and present a jazz poetry session as part of the private view, which went down very well. David came up to me and said, 'You're Michael, aren't you?' And I said, 'Yes, and you're David. I've seen you quite often.' There were also many of those who were to become dubbed the new young pop artists: Patrick Procktor, Peter Phillips, Allen Jones, all of whose work I found interesting.

Thereafter, when David and I met, we would invite each other up to have a look at works in

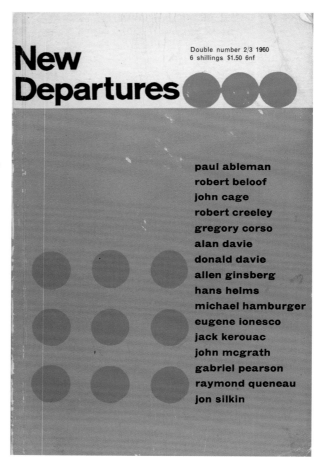

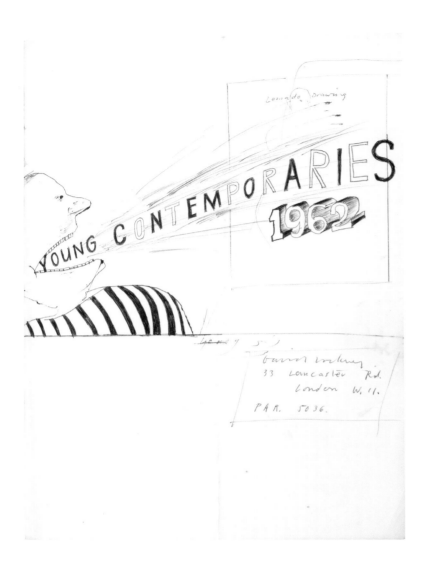

**David Hockney
Poster Design
for *Young
Contemporaries*
exhibition held at
RBA Galleries, 1962**

progress, where he had his studio and home on the first floor. There were so many different people who came through David's flat and I was very turned on by their company and conversation. In an early *New Departures*, I put portraits of the same man by both Ron Kitaj and David on adjoining pages facing each other. David was very entertaining when he talked about his portrait subjects. He described how [W.H.] Auden never stopped talking and [William S.] Burroughs never started. I was there when he and Kitaj came back from David's having drawn Auden and David mildly complained: 'He never stopped chatting and moving around. Very hard to draw, what with all those crinkles.' Kitaj for his part then responded with: 'If that's what his face is like, what must his balls be like?', which had us all laughing.

I don't think Alan Davie and David Hockney got to know each other very well. Nevertheless, the two were considerably fellow spirits. Hockney's connection with Davie was very pronounced in simple things like having interesting titles that either did or did not obviously correspond to something in the painting. That was a very new departure for art in Britain. Alan put words in different tones and styles, like, 'Banana time', 'Mango time' or bits of poetry he liked in his titles, and it certainly turned me on a lot because it was sheer poetry of a kind.

David had seen my book on Alan and he volunteered once, 'Oh, that book on Alan Davie. That's good stuff Michael. You've really scored there. I love Alan Davie's work.' He would enthuse in that way often. I think Alan, in common with David, was always impatient with being positioned in 'the art world' and with being encouraged to repeat himself. By adopting different media, going into tapestries, jewellery et al and also zooming back and forth between London and Cornwall and elsewhere around the planet, he wanted to live the life of an all-round polymath, and also inspired, private soul. David, by contrast, quite delighted being in social swims, as long as he didn't have to conform to the swimming exercise being dictated. I remember David wrote a very good article in a magazine called *The 20th Century*, which was,

'Why I am a Conscientious Objector'. I was delighted to read that and to find in a not-yet-very established contemporary artist, this social conscience based on everything he had undergone in his short life and hoping that a better world would be built.

Music and literature were quite crucial for both Hockney and Davie. Alan got very turned on to poetry when he was doing his national service.

He wrote glumly in his journal about how the other soldiers only wanted to go to the pub and talk about or chat up prostitutes. But then he wrote of his delight in finding under his bunk one day, *Leaves of Grass* by Walt Whitman. He loved Whitman's poetry and wrote in his journals of 'The wonders of Whitman'. And almost at the same historical moment David was painting onto his canvases quotes from poets including Whitman, such as

David Hockney
***Portrait of Michael Horovitz*, 1980**
Ink and wax crayon on paper
34 x 40 cm
Signed, dated and inscribed For Michael from David H Aug 5th 1980
Michael Horovitz's collection, London

Alan Davie
Mango Time 1961
Oil on canvas
121.9 x 152.4 cm
(48 x 60 in)
Private Collection,
Devon

We Two Boys Together Clinging. These two north of England and Scottish spirits, it seems to me, were connecting, like in the Paris Métro: a lighting up of connections between different but related underground tube lines.

American literature changed enormously during the 1950s when Allen Ginsberg, Gregory Corso, William Burroughs and Jack Kerouac created the beat generation, and that was hugely influential for Alan and David. The sexual or intersexual orientations of those men (at first they were only men) was an intense preoccupation of Hockney's, who was busted for importing 'Man' magazines showing male nudes and so forth. Alan, though he seemed utterly heterosexual physically, did sometimes write in his journals, how the mainspring of his practice is the erotic impulse, sort of erotic/romantic. In a way that's a part of his basic universal appeal, that however abstract they look at first, most of those pictures do somewhere contain diverse

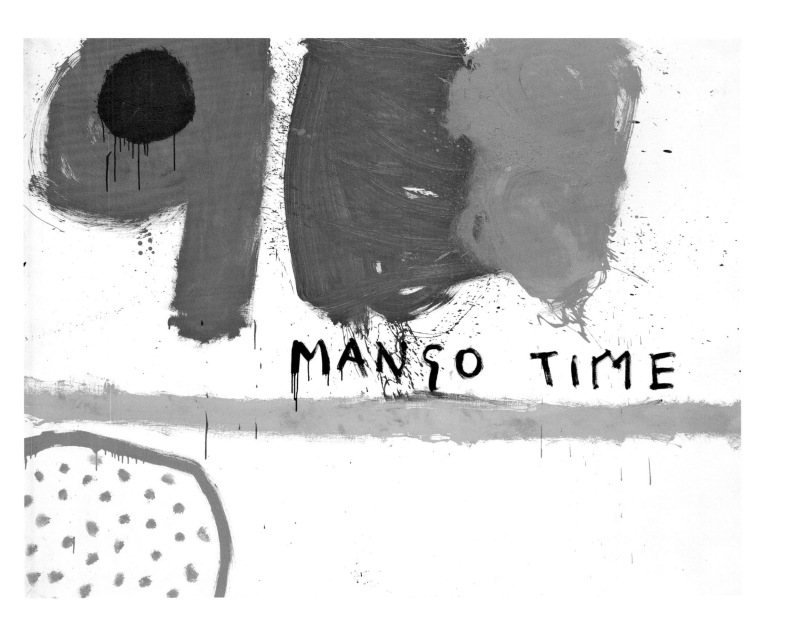

(and often exhilarating) specifics of human physical and inner experience made palpable.

Some of the poetry and literature that both of them relished was kind of traditional, the earlier kinds of jazz: Tommy Sampson's big band for example. Alan also enjoyed bebop and jump bands, and free jazz by the likes of Ornette [Coleman] and John Coltrane, where almost anything goes. The spirit of wild improvisation. He adored some of the American jazz greats: the outstandingly individualistic Sonny Rollins was one of his favourite saxophonists. But, in our conversations, Alan sometimes qualified such enthusiasm, saying that he tended to get bored in the company of some musicians, who really lived only for sex and drugs and a limited number of musical genres. They wouldn't talk about Stravinsky or Jean-Paul Sartre, whereas Alan was always open to talking about anything.

Alan would read *The Listener* every week and recommend to me books like *An Experiment with Time*, by J.W. Dunne. He was always open to intellectual speculation, and also to adventures, like *On Being A Bird*, a book about gliding and the poetic inspiration of birds, and so on. I remember him being very interested in Zen. He was also very interested in blood and things tribal. When we discussed the colour of the book for the Art in Progress series, he said: 'Make it the colour of blood'.

Likewise, if you think of Hockney, there is always this interest in all art media, and especially in music and theatre, and ballet, so each of them had different takes on this business of being a multi-media creator: it is all too often considered in rather short-sighted circles that if you've done sculpture like Michelangelo, how could you then write that huge book of sonnets, changing course in midstream? I tend to retort, as I knew Alan would, 'if the spirit moves you, houw could you not?'

Marina Vaizey[5]

I lived in London between 1961 and 1962 and then moved back in 1967 from Oxford, but I'd started to

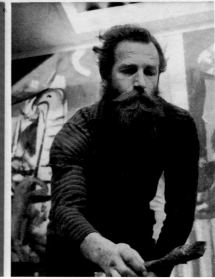

write about the visual arts in 1962, in Oxford. That's when we bought our David Hockney print, *Me and My Heroes* [1961]. Hockney was already well known because of the media, and the Bear Lane Gallery in Oxford had this exhibition sometime in 1962 of prints he'd done at the Royal College. His work was very new. The thing about the 1960s was that it became perfectly okay to talk about emotional feelings, and Hockney rode all that. He seemed a cheeky chappy from the north and somehow, although into all sorts of kinky things, also very innocent.

The London art world was extremely small, you could meet almost everybody. When I moved to London in January 1967, there were only about six contemporary galleries that anybody who was interested in the visual arts would have gone to. There was Annely Juda, Waddington – before their huge expansion – Arthur Tooth & Sons, Lefevre and there were two or three galleries in Cork Street. There was also the Rowan Gallery, which showed Bridget

Riley, Erica Brausen's Hanover Gallery, Helen Lessore at the Beaux Arts, and the Lisson opened in 1967.

There was a whole shift in atmosphere in the 1960s and things that weren't directly involved, like the auction houses, transformed the view of art. The auction houses, Sotheby's and Christie's, made a huge difference because they brought in such a lot of people for their seasonal sales. That all started in the late 1950s. They didn't have the huge New York presence they now have, so people came over for the sales and then got into modern and contemporary art. Peter Wilson of Sotheby's was somehow aware in a way that people hadn't been before of the incredible economic power of publicity. He publicised the 1958 Impressionists sale, which made huge amounts of money and headlines. So art in London became news in a way that it hadn't been before. I think that was incredibly important for altering the atmosphere.

Also, more and more people began going to museums and galleries. There was an enormous record-breaking show of Picasso at Tate in 1960. I remember it being absolutely mobbed. So things like the Picasso exhibition were making news, and then Sotheby's made news and, as a result, art became news.

The other thing that was important was Bryan Robertson and the Whitechapel. Bryan did a whole series of exhibitions of contemporary English art. He, John Russell and Tony Snowdon also did the book Private View [1965], which got an enormous amount of attention and changed people's lives because it opened up an art world to a wider audience.

It was very interesting for me, because I came from New York originally, and in New York being involved with a contemporary museum had a lot of social cachet. In Britain, it was thought if you were interested in contemporary art you were slightly nuts. Contemporary British art only started to become popular internationally in the mid to late 1960s, as part of Swinging London: Biba, The Rolling Stones, Marianne Faithfull, Celia Birtwell. And after all, David was in that whirl. The pop rock

thing was terribly important, it broke down a lot of barriers.

The other thing that happened was the democracy of art because the great print studios opened: Kelpra and Alecto. They got a lot of publicity and people began to feel they could buy art for themselves, even if they weren't rich. People were also terribly excited about the Sunday colour supplements when they began in 1962, they thought this was just amazing because they were very much focused on people.

In my opinion, Abstract Expressionism wasn't incredibly influential, although it was shown at the Whitechapel and shown beautifully. People in the know loved it, but I don't think it swamped everybody. What was important was the sense of America being the land of plenty. Ads for Coca-Cola and that kind of thing. It was American society rather than American art that was important. Britain was becoming a consumer society and it was almost eaten up with envy at the plenty of America.

What is also terribly important about the late 1960s and early 1970s, which is embodied in Hockney, is the progression of gay rights. The art world is very gay and people were leading these slightly hidden lives because it was criminal. Myself and My Heroes is political because Whitman was gay and Mahatma Gandhi, after all, was the pacifist who sat down. British art has never been that political and I think Hockney's politics are much more about individual freedom rather than transforming society.

John Loker[6]

I was only 15 when I started at Bradford [School of Art]. I did graphic design, slightly reluctantly because I didn't want to go to college at that point, I wanted to be a signwriter. I then got caught up – there was Hockney, [David] Oxtoby, Norman Stevens, some quite good painters – but the catalyst was a guy called Derek Stafford. He was fresh from the war, he'd been conscripted at 18 right at the back end of the war and went to the Royal College

on an ex-serviceman's grant and did three years there before appearing in Bradford. He was full of enthusiasm. He'd had a really bad time in the war, he was in the medical side of things and had gone into Bergen-Belsen right at the end and worked in the field hospitals. So he was full of the joys of being back out in the world again, he'd got a young group of students, all keen, and he could really work with them. He was a very traditional painter, he introduced us to Mondrian and Picasso and the usual Europeans, but also looked towards the Americans. Davie's show in Wakefield was during that period.

We used to go down to London at weekends quite often, we'd just hitchhike down. Myself and Pete Kaye, a very talented painter who also went to the Royal College, David Hockney and Norman who were in the same year, we would all hitch down over night and meet up again in London. We'd see major shows at the Tate and National galleries, and there was a big show of contemporary American art at

David Hockney
*Mirror, Mirror
on the Wall* **1961**
Etching and
aquatint
40.5 x 49.7 cm
(16 x 19½ in)
Private Collection

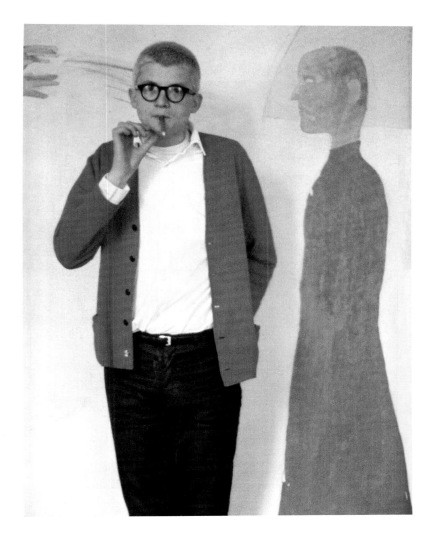

David Hockney in *Private View: the Lively World of British Art*, 1965, edited by Bryan Robertson and John Russell, photograph by Lord Snowdon

the time, which had a big influence. We were just excited about wandering down Cork Street and the West End galleries discovering whatever was on at the time (I remember seeing Picasso's Vollard suite in Cork Street), because there were always shows on apart from the bigger shows like at Tate etc. and we'd spend all weekend down there. The exhibitions didn't cost you any money and you could catch up on a bit of sleep sometimes on the gallery benches.

I remember coming to Wakefield to see Davie with Pete Kaye and David Hockney, I can't remember if Norman came too. I remember being very excited because we hit it at the right time when Davie was there, talking about his work in the gallery. To us he was just a middle-aged man, I was 17 or 18, and he had a big beard and that presence. I remember his enthusiasm and the idea that he made his own paints. It seemed quite magical, he worked on the floor and he poured it on like Jackson Pollock. It just felt so special because the teaching was quite traditional at Bradford. Hockney was doing those little streetscapes, and because of doing graphics I got into doing abstract record sleeves at the same time as doing life drawings and all the things required for the course. So coming over here and seeing works like the *Creation of Eve* [1956], what struck me was the powerful strong colour. If you see these works now, they often seem very dull and I wonder if he didn't mix his paints too well. I remember them being brighter – they were singing! Pure absolute red.

It was like the world that we'd seen in books with images like [Philip] Guston and [Willem] de Kooning and Pollock, always in reproduction. Suddenly you're seeing these works and they are life size, that struck me as well. I've always done very big paintings – as well as a lot of small paintings. Because they are bigger than me, you're actually going into something. That [in 1958] was the first time I'd been aware of painting on that scale, apart from the big Old Masters in museums. Seeing that physical presence of Davie's paintings, and photographs of him surrounded by big pots of 'homemade' paints was inspiring to a 17 year old student in the 1950s.

I remember him talking about Zen Buddhism, and transcendental meditation – that area of things, which I was never big on but it was a kind of magical side to something. In a sense, it gave content to the work. When you're younger, you think that abstract is something abstracted and made less figurative than reality is – whatever reality might be – or totally abstract i.e. like a pattern, but Davie's explanation gave it content and you realised that this abstract thing could actually be about something.

There was this striking thing that he said that I still remember clearly now. There was this painting [see pp 23 and 96] that was all reds, yellows etc., but the bottom corner of it was kind of blue, the whole corner. I think it was Pete Kaye who asked

him the question, 'Why have you done that bottom corner of the background blue when the rest is red?' We were expecting some kind of deep reason. And he said, 'because I ran out of red paint!' And to us that really made sense, we thought, 'Wow that is great'. It just seemed to be kind of cheeky, poking fun at himself in saying that, because you felt that there was a gamut of ways that he could justify that choice, but at the same time he was just throwing it away.

The other thing about Davie that struck me at the time was the fact that he worked on the floor. Apart from the tachists and the action painters riding bikes over things that came a bit later, it was seen as quite something: the canvas is on

The teenagers' lounge on P&O liner *Canberra* decorated by David Hockney in 1961 Bruce Peter Collection

Photograph (from left to right) of John Loker, Norman Stevens, David Oxtoby and David Hockney, at Bradford College, mid-1950s

the floor and he would be working on top of it, just like we'd seen in the pictures of Pollock. He would say: 'Painting is a continuous process, no beginning or end. There's never really a point in time when a painting is not.' And that's something I've always said, when people say, 'Where did that come from?', I say 'It came from that painting', and 'Where's it going?' 'It's going to whatever the next one will be', because it's a process all the time. They become individual objects. It's that kind of empathy I've had with him all my life, without really realising it.

I was always more at home with Davie's earlier work than when they got more and more symbolic. *Peach Time* is a very special painting to me, it reflects

that time in the 1960s so well. I wasn't that aware of him when I was in London really. I'd see his work and I saw pieces later but it was that experience at that young age that I really went for. David Hockney really picked up on him, though the thing that always separates his work from Davie's is that Hockney's are always so precise, careful, planned – almost mannered. They don't have that feeling, whereas Davie's works are loaded with heavyweight feeling.

For me, what took off in London was Pop art. When I look back, there was a lot of that in my work, but at the time we were working against it, because Pop art became so big. The year that followed Hockney had Pat [Patrick] Caulfield in, who became a good friend, and generally in that year

Alan Davie
***Creation of Eve* (detail) 1956**
Oil on canvas
175 x 244 cm
(69 x 96 in)
Private Collection, London

we really thought we were opposing Pop art and doing something totally different. We became quite dismissive of it in a way, because it became high fashion. I think the nature of being an artist is that you rebel against fashion.

I was much more interested in American artists like Stuart Davis, and some of those people. Stuart Davis was doing Pop art back in the 1920s and 1930s, he was the father of it really, he did a painting of a dollar bill long before [Andy] Warhol. There was a Stuart Davis exhibition in London in 1964 because there was a time when he was looked up to and better known, talked about much more, but also through other artists and people I knew at that time who would say, 'Have you seen Stuart Davis's stuff', and pass books around. And of course the art magazines then, [Art] Forum was very good and covered American art very well, and Studio International.

There was a lot of reading that went on during my time at college, we felt like we had to – it went with the territory. I particularly remember David reading Walt Whitman's Leaves of Grass, his painting We Two Boys Together Clinging was from a Whitman poem. When I think about my reading throughout college it was 19th-century French and Russian:: Dostoevsky, Goncharov, Stendhal – I felt I had to read all these things, and then I discovered George Orwell and H.G. Wells. I read a lot of science fiction at that time, Ray Bradbury and Philip K. Dick, but it was only indirectly informing my work.

Davie was a musician as well, which I quite admired. It seemed to me in those days that playing the saxophone and jazz seemed to go with abstract art. There is a kind of association there. Hockney was quite into music, but very much classical music. Somebody Norman Stevens knew had some connections with St George's Hall in Bradford, so we used to go to the concerts free, which included the jazz concerts when they were on as well. We'd sell programmes, and then we could take whatever seats were around and stay for the concerts.

Hockney's works, to me, although beautiful and very delicate are almost protective. You don't find out much about him from his painting, you find out his take on ways of seeing. He is a very talented draughtsman and through this he has explored and redefined art movements. His explorations lead us to the rarefied world of art and style. Although David Hockney's work for a time bore some visual comparisons to Alan Davie's, I find Davie's work very direct. It is expressive, full of energy and a container for his spirituality – he seems to revel in the physicality of the paint.

Lindy Hamilton-Temple-Blackwood, Marchioness of Dufferin and Ava[7]

I had a very confusing upbringing. Part of my early years were spent in Palm Beach, France, Mexico and in England. My mother longed for me to have a normal English life and sent me off with the hopes that I would end up marrying a strong, noble Englishman. On one of the endeavours I was to meet the man who changed my life, but not in the way my mother had hoped. The man was Duncan [Grant], who happened to be living in Charleston. It became this huge friendship and I was terribly close to Duncan until he died. I didn't really start thinking about art in any form until about 1962. I got a scholarship to the Slade and I was studying under [William] Coldstream. I loved German Expressionism and I absolutely adored Constable and that whole era, simply because it's very close to nature.

I met David in 1963. David is also a celebrator of life. I realised early on that he was a complete genius. When David gives me a lesson in drawing, it's absolutely incredible. He takes a piece of paper and puts his glasses on and says, 'Oh, Lindy, now, let's have a look', and then within minutes he's placed it perfectly. It just comes out of him. David was also completely non-judgemental. It didn't make any difference whether one was a duke or a murderer. It simply didn't cross his mind.

Everyone needs a house to go and have parties in, and mine was very much one of those houses. After a big opening [at Kasmin Gallery, who represented Hockney], we'd all come back

and have a do here. At that point, I was running the ICA with [Roland] Penrose and that also had to have huge parties, so it was non-stop. Stephen Spender was almost our best friend. We used to have a lot of artists come over; [Robert] Motherwell, Helen Frankenthaler, [Frank] Stella. Ron Kitaj was always round too because he was very friendly with Spender. He was very attractive and wonderfully sexy and troubled, a huge presence in the room. David, on the other hand, absolutely not. David was like 'Puck' in Shakespeare. A genius Puck.

Prior to Kasmin, my husband Sheridan was mainly buying from the Marlborough. He was very interested in [Francis] Bacon. He really formed his collecting style by employing Kas to start the gallery though. It was through him that he made the most incredible collection. He was a natural collector. He was looking at everything the whole time.

Derek Boshier[8]

I met David two years before we went to the Royal College. The Royal College interview was a two-day affair, so if you lived in the provinces you had to stay overnight. A few hundred people apply, and then it's down to 60 before they take their 18 or so. I lived in the provinces, I was in Somerset, David was in Bradford, Peter Philips was in Birmingham, Allen Jones lived here in London actually. The first day of the interview you had to sit in the life-drawing room and draw all day. So I did that and went back to the hotel and there were two guys in the hallway. One of them said, 'Were you at the Royal College?', and I said 'Yeah', and he said, 'Did you apply to the Royal College?', and I said 'Yeah', and he said, 'Tomorrow's the big day with the interview proper, do you think we'll get in?', and I said, 'I hope so!', and that was David.

We all got into the Royal College because of Carel Weight. We were brought up academically, we all painted like Carel Weight and Stanley Spencer. I was so glad because I learned how to draw a figure and that's why I'm a narrative painter – that and my working-class background and all the social things I became interested in. Later, I was criticised all the time for being multidisciplinary: 'You're a painter, what are you doing making films?'

The thing that David said: 'When I got to the Royal College everyone was doing Abstract art, so I thought I'd give it a go', well I did exactly the same. Alan Davie was the most popular Abstract artist among the students who weren't Abstract. I always thought that the way that Davie influenced David was really nothing to do with subject matter at all, it was all to do with abstract art and the gestural, and thinking, 'Oh I'll have a go'. The symbolism that hid in those early paintings of David's, that was what he turned into words.

My influence was the Spanish painter [Antoni] Tàpies. I tried that, went to Morocco and did some Tàpies-stuff on paper, and then when I got back I got involved in Pop art. The American Embassy spent thousands of dollars promoting Abstract Expressionism and pop art, and we were always going to the American Embassy, the cultural attaché selling us American Pop about which we didn't know anything at the time. I later threw bricks at it in protest of the Vietnam War. The one common denominator of all the people who did Pop art was that we were all working-class kids.

The Royal College was amazing for its diversity. The thing that all art schools want to do is get the departments working with each other. We were a sort of coterie, we used to hang out; Marion Foale and Sally Tuffin and Ossie Clark were in our little gang, and David, and there were two guys from automotive design, and the filmmaker Ridley Scott who was then doing graphic design – in his first year the Royal College started a film course and Ridley switched course. We purposely didn't want to dress like bohemians, so we used to go to college in ties, and dressed in good fashion. It was the influence of fashion in London, we were reacting against the Parisian berets.

The person that I saw quite a bit of, because he came to the Royal College two or three times a year, was William Scott. By a great coincidence

**Lord Snowdon,
David Hockney, 1963**
14 ⅝ in. x 9 ⅞ in.
(371 mm x 250 mm),
National Portrait Gallery.
Given by the photographer,
Antony Charles Robert
Armstrong-Jones, 1st Earl
of Snowdon, 2000

one of my best friends in LA is his son James, who made the first film ever on David in 1967, of David making the etchings of [Constantine] Cavafy. What James did was try to involve the artist in the film, he wanted to make films about artists at work.

The Royal College had such a good library, better than any art college. It was very good on magazines: *Domus, Art Forum* – all the American, and British – *Art Review, Studio International*, all of those. They had so much on fashion and art, at the end of the week when we knew all these magazines had come in, we went up to the library and just read for two to three hours, every magazine. And then in our minds we just totally trashed them. We wanted to see what not to do! I hadn't read a book from beginning to end until I was 16, and then it was

Wuthering Heights, but then I just read all the time, I devoured books; both fiction and non-fiction. I read so much I can't remember it all. *Hidden Persuaders*, by Vance Packard, was my thing and everyone else who talked about advertising like Marshall McLuhan. That's what turned me on.

We weren't interested in technology, we were interested in popular culture: girls' films, boys' films. I remember seeing all the Dean Martin films, musicals, Doris Day, a lot of cowboy films. There were some great cinemas – one in Hampstead where the posters were terrific, they were woodcuts. That was our introduction to popular culture. Later, when we got to college, we became semi-intellectual and watched only [François] Truffaut and [Jean-Luc] Godard. The Royal College had an incredibly good

Film still from Love's Presentation, 1966, directed by James Scott; Hockney drawing directly from photographs onto the plate

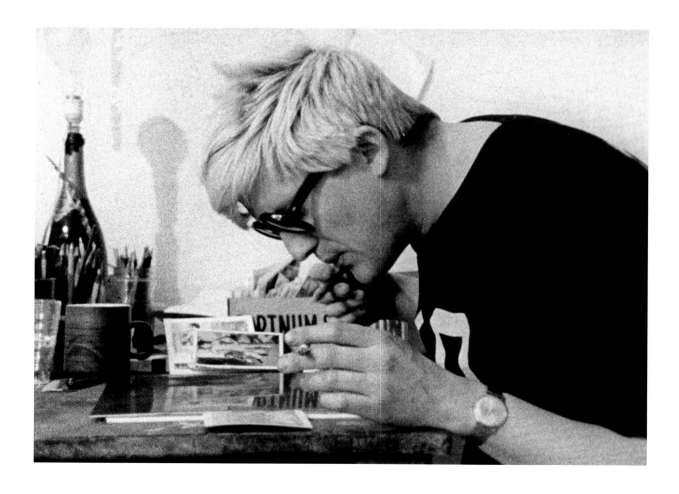

CLIFF RICHARD

Living Doll

film society. Everyone came to the film society, and the graphic people got involved and made great posters, it was like an early version of *Time Out*.

David became the star of the new Sunday magazines. The amazing thing is that not only was David gay at the time when you could go to prison for it, but he was advertising it, he was doing those paintings. I think David was covering up those things, because you had to watch it. I'm always asked, were you the DB [Doll Boy] in those paintings? But of course I wasn't, it was Cliff Richard.

1. Alan Bowness interviewed by Eleanor Clayton, 1 February 2019
2. Ronnie Duncan interviewed by Eleanor Clayton, 17 January 2019
3. Sylvia Thompson interviewed by Eleanor Clayton, 12 December 2018
4. Michael Horovitz interviewed by Helen Little and Rachel Stratton, 20 February 2019
5. Marina Vaizey interviewed by Eleanor Clayton and Rachel Stratton, 8 March 2019
6. John Loker interviewed by Eleanor Clayton, 28 January 2019
7. Lindy Hamilton-Temple-Blackwood interviewed by Helen Little, 27 February 2019
8. Derek Boshier interviewed by Hilary Floe and Helen Little, 29 September 2018

Timeline

Born in Bradford, Yorkshire

1920 **1937** **1938** **1940** **1941–6**

Second World War ends 2 September 1945. Arts Council England established in 1946

Outbreak of war on 1 September 1939

Wins Andrew Grant Travelling Scholarship – delayed until after the war

Serves in the Royal Artillery, stationed around the UK. Finds Walt Whitman's *Leaves of Grass* under his bunk in 1943

Born in Grangemouth, Scotland

Wins Andrew Grant Scholarship at Edinburgh College of Art

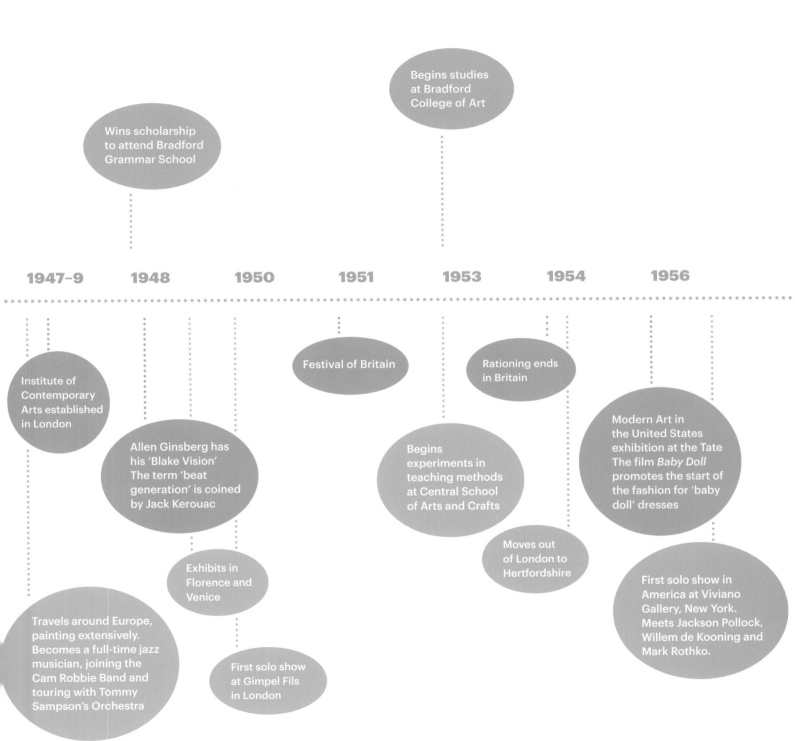

Wins scholarship to attend Bradford Grammar School

Begins studies at Bradford College of Art

1947–9 **1948** **1950** **1951** **1953** **1954** **1956**

Festival of Britain

Rationing ends in Britain

Institute of Contemporary Arts established in London

Modern Art in the United States exhibition at the Tate The film *Baby Doll* promotes the start of the fashion for 'baby doll' dresses

Allen Ginsberg has his 'Blake Vision' The term 'beat generation' is coined by Jack Kerouac

Begins experiments in teaching methods at Central School of Arts and Crafts

Exhibits in Florence and Venice

Moves out of London to Hertfordshire

First solo show in America at Viviano Gallery, New York. Meets Jackson Pollock, Willem de Kooning and Mark Rothko.

Travels around Europe, painting extensively. Becomes a full-time jazz musician, joining the Cam Robbie Band and touring with Tommy Sampson's Orchestra

First solo show at Gimpel Fils in London

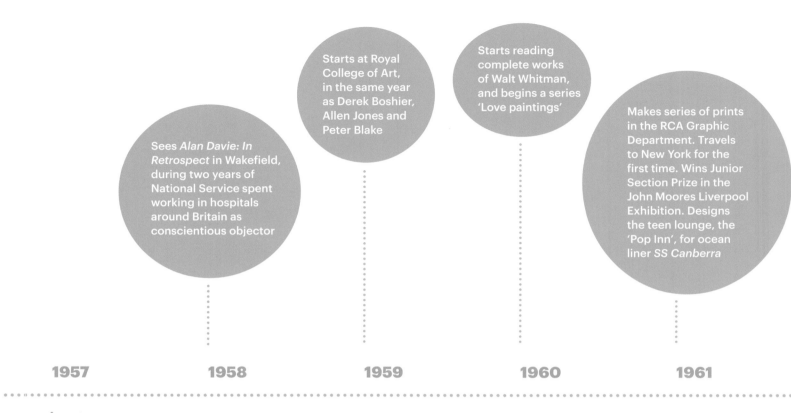

Sees *Alan Davie: In Retrospect* in Wakefield, during two years of National Service spent working in hospitals around Britain as conscientious objector

Starts at Royal College of Art, in the same year as Derek Boshier, Allen Jones and Peter Blake

Starts reading complete works of Walt Whitman, and begins a series 'Love paintings'

Makes series of prints in the RCA Graphic Department. Travels to New York for the first time. Wins Junior Section Prize in the John Moores Liverpool Exhibition. Designs the teen lounge, the 'Pop Inn', for ocean liner *SS Canberra*

1957 **1958** **1959** **1960** **1961**

Jack Kerouac publishes seminal beat novel *On the Road*

New Departures poetry journal established, with support from beat poets *New American Painting* exhibition at the Tate Ronnie Scott's Jazz Club opens in London Cliff Richard's 'Living Doll' is best-selling record of the year

Record-breaking attendance at Tate's *Picasso* exhibition

Becomes Gregory Fellow of Painting at Leeds University Elected member of the London Group

Alan Davie: In Retrospect, first solo show in a public institution, held at Wakefield Art Gallery, tours to Nottingham University, Nottingham; Whitechapel Gallery, London; and Walker Art Gallery, Liverpool

Establishes studio in converted barn 'The Gamels' in Hertfordshire

Takes up gliding and writes free verse about his experiences. Publishes 'Towards a New Definition of Art: Some Notes on NOW Painting' in *New Departures*

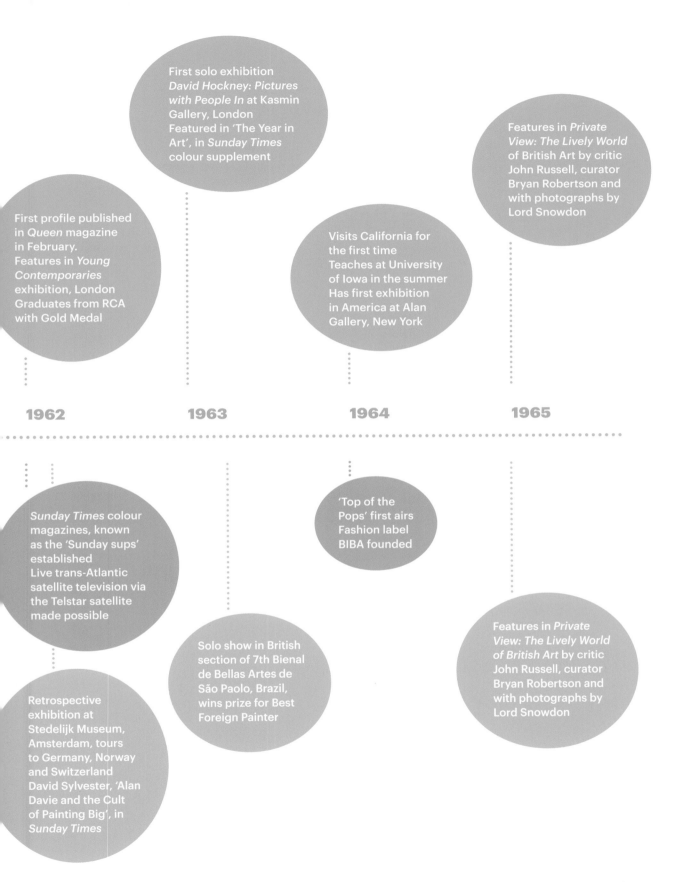

First solo exhibition *David Hockney: Pictures with People In* at Kasmin Gallery, London
Featured in 'The Year in Art', in *Sunday Times* colour supplement

Features in *Private View: The Lively World* of British Art by critic John Russell, curator Bryan Robertson and with photographs by Lord Snowdon

First profile published in *Queen* magazine in February.
Features in *Young Contemporaries* exhibition, London
Graduates from RCA with Gold Medal

Visits California for the first time
Teaches at University of Iowa in the summer
Has first exhibition in America at Alan Gallery, New York

1962　　**1963**　　**1964**　　**1965**

Sunday Times colour magazines, known as the 'Sunday sups' established
Live trans-Atlantic satellite television via the Telstar satellite made possible

'Top of the Pops' first airs
Fashion label BIBA founded

Features in *Private View: The Lively World of British Art* by critic John Russell, curator Bryan Robertson and with photographs by Lord Snowdon

Solo show in British section of 7th Bienal de Bellas Artes de São Paolo, Brazil, wins prize for Best Foreign Painter

Retrospective exhibition at Stedelijk Museum, Amsterdam, tours to Germany, Norway and Switzerland
David Sylvester, 'Alan Davie and the Cult of Painting Big', in *Sunday Times*

Notes

Love Painting / Painting Love

1 Helen Kapp, 'Foreword' in *David Hockney, Alan Davie: Drawings and Paintings* (ex.cat), University of Lancaster, Lancaster, 15–30 October 1971; Bede Gallery, Jarrow, 5–26 November 1971; Hatton Gallery, Newcastle, 1–31 December 1971; Carlisle City Art Gallery, Carlisle, 2–29 January 1972; Bondgate Gallery, Alnwick, 4–25 February 1972 and Civic Hall, Whitehaven, 3–24 March 1972, unpaginated.

2 Charles Gimpel, letter to Peggy Guggenheim, 24 July 1954, Gimpel Fils archive.

3 Alan Davie, letter to Catherine Viviano, May 1956, in Viviano's gallery records that were donated to the Smithsonian Archives of American Art, Washington. In 2003, copies of which were obtained by the author via another researcher.

4 Charles Gimpel, letter to Helen Kapp, 18 March 1958, The Hepworth Wakefield Archive, THW-2.136.

5 David Lewis, 'Introduction' in *Alan Davie: In Retrospect* (ex.cat), Wakefield City Art Gallery, 1–30 March 1958, unpaginated.

6 Alan Davie, letter to Clement Greenberg, dated 'Monday', but traced to 1956, Clement Greenberg papers, Archives of American Art.

7 Alan Bowness (ed.), *Alan Davie*, Lund Humphries, London, 1967, p.171.

8 Robert Melville, *Contemporary British Painters: Alan Davie*, Gimpel Fils, London, 1961, p.2.

9 Ibid., p.6.

10 Alan Davie, letter to James Hyman, 30 April 2003, quoted on http://www.jameshymangallery.com/artists/128/1050/alan-davie/creation-of-eve?r=artists/128/sold/alan-davie. Accessed February 2019.

11 Alan Davie, 'The Artist and the Physicist: An Exchange' (introduction to a lecture given to the Physics Society of the University of Leeds), 1957, p.3. Copy sent by Davie to David Sylvester, Tate Archive, TGA 200816/4/2/30/1.

12 Alan Davie, quoted in Lewis, 'Introduction'.

13 also see Helen Kapp, letter to Charles Gimpel, 17 March 1958, The Hepworth Wakefield Archive, THW-2-136. Alan Davie, letter to Helen Kapp, 25 July 1958, in which he writes: 'have just heard from Bryan [Robertson] that the Tate has bought the "Birth of Venus" – we are all struck dumb with astonishment – let's hope this will be the beginning of a series of purchases of work by my "forgotten generation"', The Hepworth Wakefield Archive, THW-2-136.

14 Peter Phillips, quoted in Marco Livingstone, 'Young Contemporaries at the Royal College of Art, 1959–62: Derek Boshier, David Hockney, Allen Jones, R.B. Kitaj, Peter Phillips', MA Report, Courtauld Institute of Art, London, May 1976, p.A5.

15 G.F. Watson, 'A Consideration of David Hockney's Early Painting (1960–65) and its Relationship with Developments in British and American Art of that Time', MA Report, Courtauld Institute of Art, London, 1972, unpaginated.

16 This is suggested by Watson and supported by John Loker, interview in this volume, pp 93–7.

17 Helen Kapp, letter to the *Yorkshire Post*, 18 March 1958, The Hepworth Wakefield Archive, THW-2-136.

18 As Allen Jones describes: 'English abstract painting at that time might have been different if the artists had been able to see the paintings and not the reproduction'. Allen Jones, interview, 15 March 1976, in Livingstone, 'Young Contemporaries', p.A27.

19 Marco Livingstone, *David Hockney*, Thames & Hudson, London, 1981, p.15.

20 'Davie, who was Gregory Fellow in Leeds at the time, came and talked to the people in the exhibition, answering their questions; among those Hockney.' Quoted in Watson, 'A Consideration of David Hockney's Early Painting'.

21 David Hockney, quoted in *David Hockney: My Early Years*, ed. Nikos Stangos, Thames & Hudson, London, 1977, p.40. One artist who remained uninterested in abstraction was R.B. Kitaj, who claimed 'I never made an abstract painting in my life. I was probably a grandchild of Surrealism, and still am . . .'. See Livingstone, 'Young Contemporaries', p.13.

22 Derek Boshier, interview in ibid., p.A41.

23 See Peter Phillips, interview in ibid., pp A3–A13.

24 David Hockney, *David Hockney: My Early Years*, Thames & Hudson, London, 1976, p.41.

25 Derek Boshier, interview in Livingstone, 'Young Contemporaries' P.A41.

26 Livingstone, *David Hockney*, p.21.

27 Livingstone, 'Young Contemporaries', p.39.

28 'I used to say I thought it was the first really serious painting I'd done; it is my first painting that had precision.' Quoted in Nikos Stangos (ed.), *David Hockney* by David Hockney, Thames and Hudson, London, p.62.

29 For more on Whitman's codes, see Eleanor Clayton's chapter in this volume, p.67.

30 Anton Ehrenzweig, *The Hidden Order of Art: A Study in the Psychology of Artistic Imagination*, Wiedenfeld and Nicolson, London, 1967, reprinted 1993, p.38.

31 See David Sylvester, 'Art in a Coke Climate', *The Sunday Times Magazine*, pp 14–23.

32 Alan Davie, 'Artist-Teacher: Some Thoughts', *The Times Educational Supplement*, 24 June 1960.

33 Alan Davie, 'Towards a New Definition of Art: Some Notes on NOW Painting', *New Departures*, no.2/3, 1960. Hockney's portrait drawings of the American poet William Burroughs would later appear in *New Departures*, no.15, 1983, pp 24–7.

34 Alan Davie (6 of 9), National Life Stories Collection: Artists' Lives, The British Library, London, https://sounds.bl.uk/Oral-history/Art/021M-C0466X0108XX-0600V0.

35 Bill Hare, 'Blow-Up – Between Form and

Formlessness', *Map Magazine*, no.8, Winter 2006 – November 2006, https://mapmagazine.co.uk/blow-up-between-form-and-for.

36 David Hockney and Larry Rivers, *Art & Literature*, no.5, Summer 1965.

37 Hockney, *My Early Years*, p.101.

38 Henry Geldzahler, 'Introduction', in ibid., p.10.

39 See Christopher Finch, *Image as Language: Aspects of British Art 1950–1968*, Penguin Books, Harmondsworth, 1969, pp 9–10; Philippe Garner, 'Fleeting Images: Photographs, Models and the Media – London, 1966' in Philippe Garner and David Alan Mellor (eds), *Antonioni's Blow-Up*, Steidl, Göttingen, 2010, pp 106–23.

40 Guy Brett, 'New Paintings at the Whitechapel Gallery', *The Guardian*, 28 March 1964, p.6.

41 Ida Kar, 'Le Quartier St Ives', *Tatler*, June 1961.

42 Allen Jones, interview in Livingstone, 'Young Contemporaries', pp. A14–36.

43 Robert Goodnough, 'Pollock Paints a Picture', *ARTnews*, May 1951.

44 David Sylvester, 'Alan Davie and the Cult of Painting Big', *The Sunday Times*, 2 September 1962, pp 26–7.

45 Melville, *Contemporary British Painters*: *Alan Davie*, p.7.

46 Peter Lanyon, letter to Robert Motherwell, 4 February 1961, Robert Motherwell Archive/Dedalus Foundation.

47 See David Mellor, *The Sixties Art Scene in London*, Phaidon, London, 1993, p.143.

48 Ibid.

49 See Emma Yorke, 'Clown with Vision', *Town*, September 1962.

50 Bryan Robertson, 'The New Generation: The Pitfalls', *The Times*, 17 December 1963, quoted by Mellor, *The Sixties Art Scene*, p.143.

51 Bryan Robertson, John Russell and Lord Snowdon, *Private View: The Lively World of British Art*, Nelson, London, 1965, p.235.

52 Nigel Gosling, 'A Boom for the British', *The Observer*, 2 June 1963.

Sing Me the Universal

1 Walt Whitman, *Leaves of Grass*, Oxford University Press, Oxford, 1990, p.50.

2 Alan Davie, 'I Confess' in *Visione Colore* catalogue, Palazzo Grassi, Venice, July – October 1963, reprinted in Bowness, *Alan Davie*, p.19.

3 Alan Davie (2 of 9), National Life Stories Collection: Artists' Lives. The British Library, London, https://sounds.bl.uk/Arts-literature-and-performance/Art/021M-C0466X0108XX-0200V0.

4 Ibid.

5 Reprinted in Bowness, *Alan Davie*, p.7.

6 Ibid., p.19.

7 Alan Davie, 'The Artist's Experience of Art', extracts from a lecture given at Nordisk Brukskunst Kongress, Lillehammer, Norway, August 1966, reprinted in Bowness, *Alan Davie*, p.20.

8 Whitman, *Leaves of Grass*, p.181.

9 Jerome Loving, 'Introduction' in ibid., p.viii. Boston's District Attorney and civil authorities declared *Leaves of Grass* obscene literature and banned its distribution. In 1860 Whitman was advised by fellow writer Ralph Waldo Emerson to cut *Leaves of Grass* to give it a 'chance to be properly seen', and Whitman replied, 'You think that if I cut the book there would be a book left?' Horace Traubel, *With Walt Whitman in Camden*, M. Kennerley, New York, 1914, vol. 3, p.439.

10 Michael Horovitz, interviewed 13 February 2019.

11 Whitman, *Leaves of Grass*, p.46.

12 Interview with Hockney, May 2010, quoted in Christopher Simon Sykes, *Hockney: The Biography*, Century, London, 2011, p.70.

13 Hockney, *My Early Years*, p.87.

14 Whitman, *Leaves of Grass*, p.90.

15 Ibid., p.102.

16 Hockney, *My Early Years*, p.87.

17 Whitman, *Leaves of Grass*, p.108.

18 Ibid., p.90.

19 Hockney, *My Early Years*, p.44.

20 Whitman, *Leaves of Grass*, p.45.

21 Ibid., p.48.

22 Sykes, *Hockney*, p.92.

23 Hockney, *My Early Years*, p.87.

24 Ibid.

25 Whitman, *Leaves of Grass*, p.107.

26 Sculley Bradley (ed.), *Walt Whitman – Leaves of Grass and Selected Prose*, Rinehart Winston, New York, 1949, p.109.

27 Whitman, *Leaves of Grass*, p.105.

28 See Michael Horovitz, interview in this volume, p.85.

29 Alan Davie (2 of 9), National Life Stories Collection: Artists' Lives, The British Library, London, https://sounds.bl.uk/Arts-literature-and-performance/Art/021M-C0466X0108XX-0200V0.

30 Whitman, *Leaves of Grass*, p.30.

31 Alan Davie (3 of 9), National Life Stories Collection: Artists' Lives, The British Library, London, https://sounds.bl.uk/Arts-literature-and-performance/Art/021M-C0466X0108XX-0300V0.

32 Ronnie Duncan interview in this volume, pp 83–4.

33 G.F. Bentley (ed.), *William Blake: Selected Poems*, Penguin Classics, London, 2005, p.295.

34 Michael Horovitz, interview in this volume, pp 86–90.

35 Luke Walker, 'William Blake in the 1960s: Counterculture and Radical Reception', PhD thesis, University of Sussex, June 2014, http://sro.sussex.ac.uk/id/eprint/53244/1/Walker%2C_Luke.pdf, p.44, accessed 22 March 2019.

36 Ibid., p.2.

37 Bentley, *William Blake*, p.53.

38 Ibid., p.97.

39 Ibid., p.255.

40 Hockney, *My Early Years*, p.64.

41 Ibid., p.44.

42 Andrew Brighton and Alex Farquharson, 'Hockney's Courage' in *David Hockney 1960–1968: A Marriage of Styles*, Nottingham Contemporary, Nottingham, 2009, p.74.

43 Alan Davie, quoted in *Alan Davie / John Bellany: Cradle of Magic*, Other Criteria Books, London, 2019, p.19.

44 Mel Gooding (ed.), *Patrick Heron: Painter as Critic*, Tate Publishing, London, 1998, pp 106–7.

45 Michael Horovitz, interview in this volume, pp 86–90.

Further reading

Alan Davie / John Bellany: Cradle of Magic, Other Criteria Books, London, 2019, p.19.

Bentley, G.F. (ed.), *William Blake: Selected Poems*, Penguin Classics, London, 2005.

Brett, Guy, 'New Paintings at the Whitechapel Gallery', *The Guardian*, 28 March 1964, p.6.

Alloway, Lawrence, *Nine Abstract Artists*, Tiranti, London, 1954.

Bowness, Alan (ed.), *Alan Davie*, Lund Humphries, London, 1967.

Bowness, Alan, '"One Sign of Vigour": British Painting in the Sixties', *Town*, vol.4, no.6, June 1963, pp 62–3.

Bradley, Sculley (ed.), *Walt Whitman – Leaves of Grass and Selected Prose*, Rinehart Winston, New York, 1949.

Andrew Brighton and Alex Farquharson, 'Hockney's Courage' in *David Hockney 1960–1968: A Marriage of Styles*, Nottingham Contemporary, Nottingham, 2009.

Davie, Alan (2, 3 and 6 of 9), National Life Stories Collection: Artists' Lives, The British Library, London, https://sounds.bl.uk/Arts-literature-and-performance/Art/021M-C0466X0108XX-0200V0; https://sounds.bl.uk/Arts-literature-and-performance/Art/021M-C0466X0108XX-0300V0; https://sounds.bl.uk/Oral-history/Art/021M-C0466X0108XX-0600V0.

Davie, Alan, 'Artist-Teacher: Some Thoughts', *The Times Educational Supplement*, 24 June 1960.

Davie, Alan, 'Towards a New Definition of Art: Some Notes on NOW Painting', *New Departures*, no.2/3, 1960.

Ehrenzweig, Anton, *The Hidden Order of Art: A Study in the Psychology of Artistic Imagination*, Wiedenfeld and Nicolson, London, 1967, reprinted 1993.

Finch, Christopher, *Image as Language: Aspects of British Art 1950–1968*, Penguin Books, Harmondsworth, 1969.

Garner, Philippe, 'Fleeting Images: Photographs, Models and the Media – London, 1966' in Philippe Garner and David Mellor (eds), *Antonioni's Blow-Up*, Steidl, Göttingen, 2010, pp 106–23.

Geldzahler, Henry, 'Introduction', in David Hockney, *David Hockney: My Early Years*, Thames & Hudson, London, 1976.

Gooding, Mel (ed.), *Patrick Heron: Painter as Critic*, Tate Publishing, London, 1998.

Goodnough, Robert, 'Pollock Paints a Picture', *ARTnews*, May 1951.

Gosling, Nigel, 'A Boom for the British', *The Observer*, 2 June 1963.

Hare, Bill, 'Blow-Up – Between Form and Formlessness', *Map Magazine*, no.8, Winter 2006 – November 2006, https://mapmagazine.co.uk/blow-up-between-form-and-for.

Hockney, David, *David Hockney: My Early Years* ed. Nikos Stangos, Thames & Hudson, London, 1976.

Kapp, Helen, letter to the *Yorkshire Post*, 18 March 1958

Kapp, Helen, 'Foreword' in *David Hockney, Alan Davie: Drawings and Paintings* (ex.cat), Northern Arts Association, Lancaster, 1971.

Kar, Ida, 'Le Quartier St Ives', *Tatler*, June 1961.

Lewis, David, 'Introduction' in *Alan Davie: In Retrospect* (ex. cat), Wakefield City Art Gallery, 1958.

Livingstone, Marco, 'Young Contemporaries at the Royal College of Art, 1959–62: Derek Boshier, David Hockney, Allen Jones, R.B. Kitaj, Peter Phillips', MA Report, Courtauld Institute of Art, London, May 1976.

Livingstone, Marco, *David Hockney*, Thames & Hudson, London, 1981.

Loving, Jerome, 'Introduction' in Walt Whitman, *Leaves of Grass*, Oxford University Press, Oxford, 1990.

Mellor, David, *The Sixties Art Scene in London*, Phaidon, London, 1993.

Melville, Robert, *Contemporary British Painters: Alan Davie*, Gimpel Fils, London, 1961.

John Pearson, 'The Barons of Bond Street', *The Sunday Times Magazine*, 17 March 1963.

Robertson, Bryan, John Russell and Lord Snowdon, *Private View: The Lively World of British Art*, Nelson, London, 1965.

Sykes, Christopher Simon, *Hockney: The Biography, 2 vols*, Century, London, 2011.

Sylvester, David, 'Alan Davie and the Cult of Painting Big', *The Sunday Times*, 2 September 1962, pp 26–7.

Sylvester, David, 'British Painting in the Sixties', *The Sunday Times Magazine*, 2 June 1963.

Traubel, Horace, *With Walt Whitman in Camden*, M. Kennerley, New York, 1914.

Walker, Luke, 'William Blake in the 1960s: Counterculture and Radical Reception', PhD thesis, University of Sussex, June 2014, http://sro.sussex.ac.uk/id/eprint/53244/1/Walker%2C_Luke.pdf, accessed 22 March 2019.

Watson, G. F., 'A Consideration of David Hockney's Early Painting (1960–65) and its Relationship with Developments in British and American Art of that Time', MA Report, Courtauld Institute of Art, London, 1972.

Whitman, Walt, *Leaves of Grass*, Oxford University Press, Oxford, 1990.

Yorke, Emma, 'Clown with Vision', *Town*, September 1962.

Image credits

Arts Council Collection, Southbank Centre: 21, 52, 64

Bruce Peter Collection: 94

Courtesy of Abbot Hall Art Gallery, Lakeland Arts Trust, Kendal, Cumbria: 65

Courtesy David Hockney Inc.: 2, 6-7, 15, 27, 30, 31, 32, 35, 37, 43, 45, 52, 63, 66-67, 68, 71, 98; Richard Schmidt: 15, 27; The British Council: 46; Fabrice Gibert: 49; Prudence Cuming Associates: 51, 58, 64.

Courtesy David Ware: 55

Courtesy of John Loker © Rod Taylor: 95

Courtesy Lyndsey Ingram Ltd, London: 63

Courtesy of Michael Horovitz, Editor-Publisher of New Departures © Michael Horovitz: 86

Courtesy of Parlophone Records Limited: 101

Courtesy of James Scott © James Scott: 100

National Museum Wales: 50, 73

© National Portrait Gallery, London: 53, 99

Paul Tucker © Courtesy The Estate of Alan Davie: 18, 22, 24, 36

Photography Antonia Reeve, © National Galleries of Scotland: 12, 14, 19, 38, 48, 62

Royal College of Art: 77, 81, 82

© The Snowdon estate: 56, 57, 83, 84-5, 97, 99

Index